NEVER LATE FOR HEAVEN

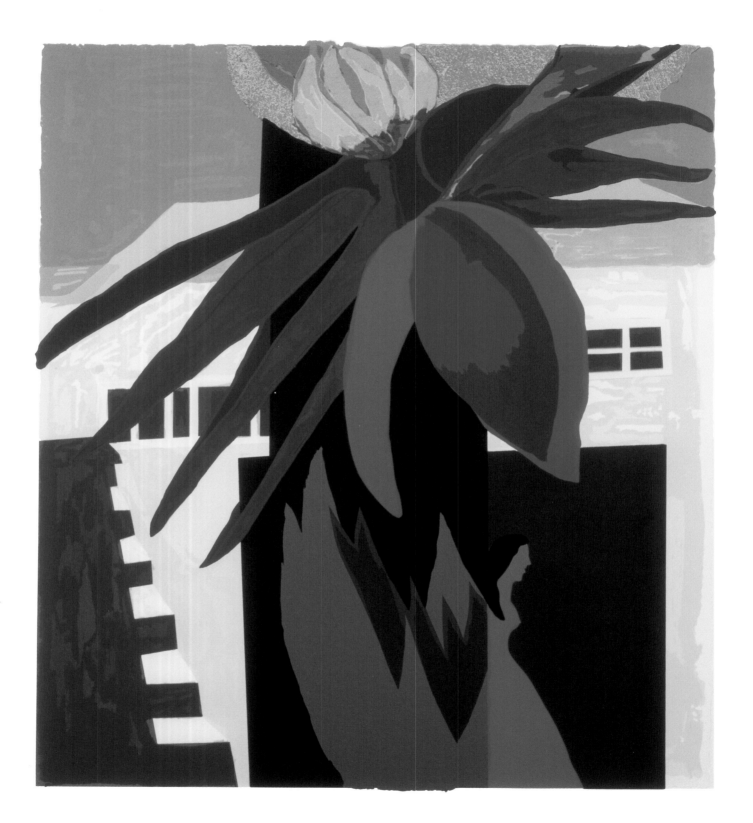

Foreword by

Janeanne A. Upp

and essays by

Sheryl Conkelton

and

Barbara Earl Thomas

THE ART OF **GWEN KNIGHT**

Never Late for Heaven

University of Washington Press *Seattle and London*
in association with the
Tacoma Art Museum *Tacoma*

Never Late for Heaven is published in conjunction with an exhibition of Gwen Knight's paintings at Tacoma Art Museum, January 14–May 3, 2003.

Library of Congress Cataloging-in-Publication Data
Knight, Gwendolyn.
 Never late for heaven : the art of Gwen Knight / foreword
 by Janeanne Upp and essays by Sheryl Conkelton and Barbara
 Earl Thomas.
 p. cm.
 ISBN 0-295-98312-4 (alk.)
 1. Knight, Gwendolyn—Exhibitions. I. Conkelton, Sheryl.
 II. Thomas, Barbara Earl. III. Tacoma Art Museum. IV. Title.
 N6537.K615 A4 2003
 709'.2—dc21

 2002152194

Frontispiece: *Untitled* (*New Orleans* series), 1941 (page 42)

Designed by John Hubbard
Color separations by iocolor, Seattle
Produced by Marquand Books, Inc., Seattle
 www.marquand.com
Printed and bound by C&C Offset Printing Co., Ltd., Hong Kong

Contents

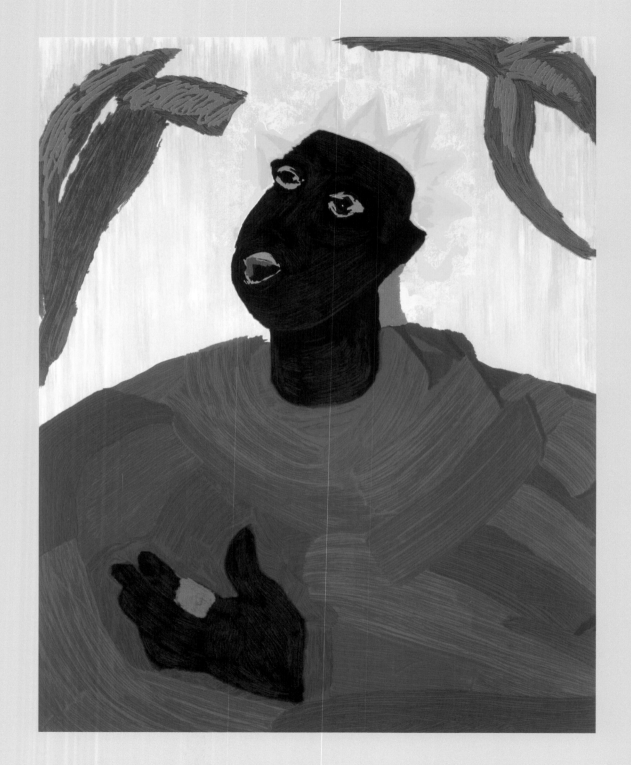

DIVA
1994, serigraph, 28 × 23 inches

Foreword

The art of Gwendolyn Knight exudes a graceful strength. Over the years, Gwen has crafted a poignant artistic expression in step with her times and true to her nature. Tacoma Art Museum is extremely honored to present the works of this extraordinary artist.

The title for this catalogue and exhibition comes from Gwen's early life: her mother teased her that she would be "late for heaven" because she was never on time. Born in Bridgetown, Barbados, West Indies, in 1913, she spent her childhood in Barbados and in St. Louis and Harlem. Living in Harlem during the years of its dramatic cultural renaissance in the 1920s, '30s, and '40s, when many African Americans migrated north to urban centers and sought a new, resonant voice for their identity, Knight was at the very center of an outpouring of talent and ideas. As a developing artist, she could look to important models close at hand—from philosopher W.E.B. Dubois to writer Langston Hughes to artist Romare Bearden. Augusta Savage, a sculptor, teacher, and energetic force in Harlem, proved an exceptionally strong mentor for the young Knight, who said, "by looking at her I understood that I could be an artist if I wanted to be." Some seventy years after classes with Savage from 1933 to 1937 at the Harlem Community Art Center, Knight has produced a vibrant body of work, attesting to the artistic wealth she "understood" and gleaned from these formative years.

Much American art of the 1930s and 1940s focused on representational scenes of commonplace activities and people. American scene painting often also carried a strong social message about the value of earnest work and simple folk. Gwen Knight's husband, the eminent artist Jacob Lawrence, contributed to this vein by depicting the lives and historical narratives of African Americans. In her art, Knight has embraced and lyrically depicted the warm intimacy that arises from everyday moments, yet she has avoided social comment, which she regards as not relevant to her own artistic expression.

First and foremost, Tacoma Art Museum thanks Gwen Knight for graciously working with us on this project. As guest curator of the exhibition, Sheryl Conkelton's insights have created a moving, memorable presentation of Knight's work. Through Barbara Thomas's essay we see a sensitive depiction of Knight as both person and artist.

Our special thanks goes to Francine Seders, of Francine Seders Gallery, whose guidance has been invaluable. I would like to extend our grateful appreciation to those individuals and institutions that have so generously lent works from their collections for this exhibition. And as always, our partnership with the University of Washington Press has been effortless and rewarding.

Janeanne A. Upp
Executive Director
Tacoma Art Museum, Tacoma

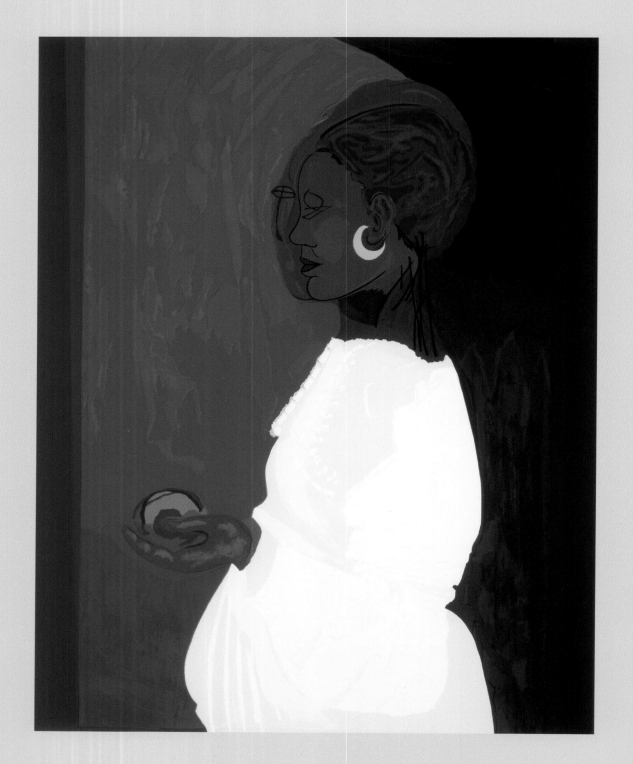

THE WHITE DRESS
1999, serigraph, 28 × 23 inches

BARBARA EARL THOMAS

Never Late for Heaven

I t was a hot St. Louis July day in 1920 when Gwendolyn Knight arrived in the United States from Barbados with her foster family. She was seven years old. Gwen's father, Malcolm Knight, had died when she was two, leaving her to the care of her mother, Miriam. She was their only child. Though these surely must have been difficult times, Gwen pieces together a recollection that is both loving and practical. "I remember," she says, "that my mother was crippled by a leg injury she had suffered some years earlier in a hurricane, and when she became a widow, I think her physical condition made it difficult for her to look after me alone. There was a family on the island with whom we were very close. They would become my foster family. When they decided to move to the United States, it was decided that I would go with them." Gwen recalls that she felt no apprehension or concern over making the change.

Her time on the island was brief but formative. She had close, loving relationships with her mother and both sets of grandparents. Her father was a white Barbadian whose family fully accepted her as their grandchild, and she visited them often. The same was true of her mother's family. She remembers especially her maternal grandfather. "He was very dark and beautiful. I was particularly close to him. I still have vivid memories of him." Somehow this love sheltered her from any misgivings about where and with whom she would live.

Leaving the tropics of Barbados changed young Gwendolyn's life. When winter swept into Missouri that year, she saw snow for the first time along with a dramatic shift of seasons. "I remember everyone sliding and playing in the snow. It was hard to know what to make of it." But she quickly adjusted to the change of worlds. In St. Louis, she and her family moved into an apartment on Cook Avenue in a brownstone building with a doorman, a nice entryway, and an elevator. Her family occupied the street-level flat. The Turner family lived above them with their five-year-old daughter, Sara. Gwen took charge of Sara. "I took care of her as if she were my own. I was very bossy, you know!"

The neighborhood in which she now found herself was a thriving, all black, middle-class community filled with children. Her family had come to this land for a new life and new opportunities. There were feelings of optimism and excitement. Even the children were industrious, Gwen recalls. "We would get together and come up with business schemes and things to sell to the neighbors, like subscriptions to a local publication. We didn't go out of our neighborhood; we weren't allowed to do that. But all the parents bought what we were selling."

Gwen was an outgoing child who laughed easily. She loved to sing and dance, and she'd perform for anyone who paid attention. She had a ready audience in her foster father, Mr. James, a barber, and her foster mother, Isabel Desmora James, a homemaker. There were also two girls, their niece Violet and their daughter Millicent, who were quite a bit older than Gwen and actually served as guardians rather than sisters. Millicent was in fact Gwen's godmother, and she and Violet both looked after her.

Six years after their arrival, as Gwen completed grammar school, another move appeared on the horizon. She and her family gathered their belongings and made preparations to go east to New York City. Although she was on the threshold of her teens, she didn't resist. "It was all very exciting. The idea of moving and seeing new things occupied all my time. I don't remember feeling sad or regretful. Maybe it was because I was leaving grammar school; it seemed like a natural break."

New York presented an altogether different landscape from any Gwen had known. It was a big, bustling city, full of life. "In St. Louis we had lived in a totally black neighborhood, but in New York I became aware of all kinds of people. There were Jews, Italians, and Poles. There were different languages and a lot of activity. It was 1926 and Harlem was at its height of life and vibrancy."

Gwen enrolled as a freshman in Wadleigh Annex and then moved on to Wadleigh High School for Girls in her sophomore year. Wadleigh had a reputation for good scholarship, and it was one of the few integrated schools in New York. Its student body was mostly Jewish, with a handful of black and Italian girls. "It was a good school, but I don't think I was the best student. As for racial problems, I don't think we had any or maybe we just didn't discuss it, but there were really no racial issues that came up. We were who we were. We were together at school but that was that. There were a few girls who wanted to feel my hair. That was funny. They would go, 'Oh it's so soft!' like they were really surprised. I spent most of my time with my two best friends, Dolly and Marguerite. We stuck together because we had lots in common, but mostly because we were from the same neighborhood. We called ourselves the three musketeers."

Gwen was an avid reader, and she also loved opera, theater, and dance. "There was a great secondhand book store on 125th Street, and while I don't remember at that point being involved in art, that is, painting and drawing, I would still sing and dance for anyone in my family who could bear it. At Wadleigh there was one teacher who seemed to recognize that, while I wasn't a scholar, I was artistic in my way of seeing things. She was very supportive of me. She was an artist, and I remember her clearly. She wore long strands of beads and dramatic clothing. Maybe she even lived in Greenwich Village. She seemed the type. There was so much going on. School was only a few blocks from my house, but even so, I would nearly always be late out the door rushing to get to school on time. My mother would laugh and call after me: 'You'll be late to heaven!'"

There was also the church. In the West Indies, the family had traditionally participated in the Anglican communion of the Church of England. "I loved all the rituals but I wasn't really involved as a young child in the activities of the church. In the States, we became Episcopalians. It was high church and formal." But the church was one of the few places where Gwen encountered the ills of color prejudice and social ranking within the black community. Those with a lighter skin were favored, and snobbish preference was accorded in terms

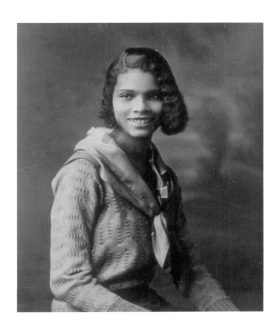

Fig. 1. Portrait of
Gwendolyn Knight
at 17 years old, 1930.

of who your family was and what they did for a living. Gwen
found this divisiveness tiresome, and she soon stopped
attending church altogether.

When asked about the racial climate of the time, Gwen
finds little to remark upon. "It's how we lived. We were in
our community and everyone was black. We had everything
we needed. There were stores for food and clothing; there
were churches and theaters, parks and schools. There was no
need to look for things outside of that world. I do remember
once going to apply at a typing school on 123rd and Lexing-
ton. I was told upon entering the door that the school didn't
take colored students. I don't remember being especially hurt.
I think I had so much support from my family and community
that I thought it just wasn't my problem; it just sort of passed
over my head. The prejudice was there, but I didn't dwell on
it. I just went on to the next thing. Maybe from having lived
some part of my life in Barbados, I didn't feel the difference
between whites and blacks so sharply. My father, who died
when I was just a baby, was white. His relatives accepted me
and included me in their family, so I didn't feel isolated or
rejected. My mother was black, and that family also accepted

and loved me. So there wasn't a problem there for me. I was
from a family of free thinkers."

Gwen and her foster family were free thinkers as well,
which meant that they didn't always adhere to the subtleties
of the social rules with regard to race. The goal of West Indian
immigrants in the United States was to seek a better life. They
were aggressive in this endeavor. They might ask forthright
questions, and they might seek work or apply for positions
not thought of as opportunities for Negroes simply because
they didn't know they weren't supposed to try. This sometimes
caused tension between the American-born blacks and those
from the Caribbean, but more linked them than divided them.

Gwen graduated from Wadleigh High School in 1930. In
her yearbook, a classmate, Dorothy Hartman, wrote: "A quiet
miss—who can tell? Still water runs deep—From your editor,
Dorothy." Gwen had clearly not shared her artistic proclivities
in that setting, but the seeds were there. On summer nights she
went with her friends to concerts and the theater, and, when
her parents gave permission, to the vaudeville shows. And there
was the Savoy, where they ventured out on occasion to dance.
One of the most famous nightspots in Harlem, the Savoy also
drew whites from the other boroughs who came to partake
of the spirit that was alive in the music and the community.
The rich melodies of "Mood Indigo" were new that year—
Duke Ellington and Billy Strayhorn were making music in the
era of the lindy's fancy footwork, when well-dressed couples
moved together in intricate, syncopated steps to swing and big
bands. "I loved to dance, but I didn't do the fancy stuff. No
one ever tossed me over their shoulder or slid me through
their legs."

Shortly after her graduation, the family had moved to 1851,
an apartment building on Seventh Avenue that was, coinci-
dentally, also home to Billy Strayhorn and Ethel Waters. "We
knew of all the jazz greats, the musicians and singers," Gwen
recalls. "I don't think any of us ever talked to Mr. Strayhorn
or Miss Waters, but we knew they were there." Miss Waters
could be seen on occasion strolling the hallway, memorably

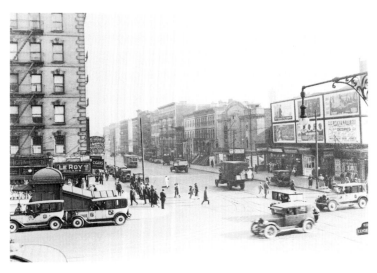

Fig. 2. New York, circa 1930. © Bettmann/CORBIS.

elegant in riding breeches, flicking her riding crop from side to side. Despite her equestrian dress, the "purebred steed" awaiting her at curbside was a limousine.

Gwen passed the summer days in Central or Riverside Parks, perched on the ancient rocks, reading or gathering with friends. This was her backyard, her piece of nature. There was no thought of matrimony or settling down. There were friends, parties, and community get-togethers. Her family prescribed her world, and by this time it was already decided that, come fall, she would attend Howard University.

Howard, a private black college in Washington, D.C., was Gwen's first venture away from home and her first co-educational school experience. It was a good period in her life but not necessarily an artful one. She says, "I was smart but no more scholarly than in high school." But she loved the lectures and the learning, and she loved meeting people. She declared her major in art right away, but Howard didn't play a major role in her development as a painter. Her classes were in the academy tradition, in which she drew and painted from the sculpted cast. She found support from Lois Mailou Jones, an ambitious young art professor in her first years of teaching at Howard. Jones was among a handful of black women painters

to emerge as artists defining that period. Of the other instructors, she remembers that Professor James Wells was also supportive. A number of professors were simply indifferent. According to Gwen, this was typical of the time. "Most people looked at women artists as if they were merely china painters or painters on velvet. So they weren't really serious about pushing us." It was bothersome, though it wasn't something she protested at the time. But it diminished the idea that Howard was going to be a supportive home for her and her art.

It was at the end of her second year at Howard, when the Depression forced her to cut her formal education short, that Gwen's real art education began. She returned to Harlem and to her family. The Works Progress Administration (WPA) was in full swing, and of this period in her life, she says: "I just had no thought of the future. I lived very much in the present; it was so alive." She settled back into her life in Harlem and joined Augusta Savage, an established sculptor who ran an artists' workshop, the Savage Studio of Arts and Crafts, and who was also the first director of the WPA-funded Harlem Community Art Center. A self-possessed artist and educator, Savage went into the neighborhood and pulled in young, talented black artists to work with her. Gwen studied sculpture with Savage and painting with Angela Straighter. A faithful daily attendee, she drew and painted from live models and developed her figure-drawing and portrait skills in paint and clay.

The Savage Studio was like a second home for Gwen. There, as she had not at Howard, she found support, a place for her work, and a way to be with others who were also working on their art and in the arts community. She recalls hearing Claude McKay speak. "I remember him because he always caused quite a stir when he appeared. I had a brief conversation with him where I commented about the classical forms in African art. Claude misunderstood my comment and thought I was saying that African forms came from or referred to Greek and Roman classical work, which was not at all what I meant. He went into an uproar, you know, and there was no way to get his attention. I think I was ahead of him on that issue."

McKay, Jamaican-born in 1890, was a poet and a black revolutionary thinker. He and Langston Hughes, along with artists such as Charles Alston and Augusta Savage, were at the heart of the Harlem Renaissance, which had been set in motion by the black northward migration, more than a decade before Gwen came of age. Even as the Renaissance waned, there ensued the burgeoning New Negro Movement, shepherded in the mid-1920s by Alain Locke, a professor at Howard University. The Movement encouraged Negro artists to connect with their African past and discover the essence of classical African forms, incorporating these elements into their work. It raised debate in the arts community among both painters and writers. Some artists chafed at the thought that there should be any rules or expectations governing the content or execution of their artwork, and others embraced the concept. "Race work" was an idea that divided the literary landscape between black writers like Langston Hughes, a race man, and Countee Cullen, a classicist. After readings and exhibitions, Gwen and other artists all over Harlem met at the Horn and Hardart Automat to get a bite and to discuss and debate the topics of the day or the artwork they'd seen at the latest exhibits.

New York was vibrant. Books were again an important source for expanding Gwen's world. The first art book she purchased was C. J. Bulliet's *The Significant Moderns and Their Pictures*. She spent lots of time browsing the galleries and museums looking at the work. One of Gwen's favorite New York haunts was An American Place, the Alfred Stieglitz gallery. She thought of the artwork there as the basis for American art. Of the artists in his stable, Gwen was most drawn to the work of Arthur Dove. She liked Georgia O'Keeffe's work, but in general she found her work too cool—elegant but distant. "That was a great education—to see all that magnificent work in museums and what was happening in the galleries. Everything I needed was right there." In Washington, D.C., galleries and major museums like the Corcoran were off limits to blacks, but in New York, the WPA was funding community art centers and sponsoring murals in public places, where all could participate.

Gwen and many artists of that period gained significant experience that defined and shaped their vision and careers for the rest of their lives.

By the mid-1930s, Gwen found herself working with graphic designer and painter Charles Alston on the Harlem Hospital mural project. She was part of a team working on a children's mural that, to her knowledge, was never installed. She left the project in 1934 to concentrate on her painting in the Augusta Savage studio. It was during this period, while visiting Charles Alston's studio in the Harlem Community Art Center, that she encountered a quiet, serious young man working away in a corner of the studio, absorbed in his painting. This was Jacob Lawrence. The young painter, who was not quite seventeen, was too young for the WPA project, but he was working with Alston and renting studio space there for two dollars a week. Gwen was drawn to his quiet seriousness, but being nearly five years his senior, she thought him very young. She was present when the studio celebrated Jacob's seventeenth birthday. "He had beautiful skin and long beautiful eyelashes that anyone would die for." Their social circles would eventually merge, and over the next few years they would see more and more of each other.

In 1940 Jacob was awarded a Julius Rosenwald Fellowship to complete his *Migration of the Negro* series. With part of his funds, he rented a large, unheated space at 33 West 125th Street. Artists' studios occupied the upper floors of a brownstone with commercial businesses on the ground level. When word of the space got out, Jacob was soon joined by painters Romare Bearden, Robert Blackburn, Ronald Joseph, and writers Claude McKay and William Attaway. Each artist had a space to himself. The spaces in the front rented for ten dollars per month; the ones in the back, for eight. It was a lively environment with serious young artists who actively discussed their work and the philosophies of the day. Gwen painted there on occasion but still regularly attended the Savage painting workshop. She completed a number of portraits of Jacob during this period, but none apparently survives.

Gwen and Jacob saw each other frequently. In the evening, he often made his way out of the studio to have dinner with Gwen and her family. When Jacob received his stipend, they took five dollars and bought his food. "You can't imagine the amount of food you could buy for five dollars. It was amazing. There was no hot water or refrigeration in that building, but in the winter you could keep things cold by setting them out on the fire escape." Gwen split her time between painting and assisting Jacob in the preparation of sixty gessoed boards that he used for the *Migration* series.

In 1941 Gwen Knight and Jacob Lawrence slipped away to City Hall, where they were quietly married. They lived either at Jake's studio or Gwen's foster parents' home while Jacob completed the *Migration of the Negro* series. Once it was finished, they decided to travel south on a grant Jacob received. Neither had traveled or lived there before, and they both wanted southern urban and rural painting experience. Although Gwen wanted to go to Mexico, Jake was not keen for it, so they chose New Orleans, Louisiana, as their urban destination, and for the rural life, Lenexa, Virginia.

While it wasn't Mexico, Gwen welcomed the warm tropical weather. It reminded her of Barbados. In New Orleans, they lived with the Jones family. In those days there were few hotels for blacks. Black travelers found space to rent in private homes with "rooms to let," a common practice among homeowners before the days of motels. And that was the case with the Joneses. Gwen and Jacob rented a room in which they both worked. Jake researched his John Brown series and Gwen explored her surroundings, painting people and scenes of daily life. The Joneses were kind people and took right away to the two young painters. They included them in their family gatherings and their Thanksgiving celebration. Nonetheless, Gwen and Jacob's stay with the Joneses was briefer than expected. Because of World War II, no Mardi Gras celebration was scheduled for February, which was part of what had drawn them to the city.

By February they had moved on to Lenexa, Virginia, for their rural experience. Here they were housed by some of

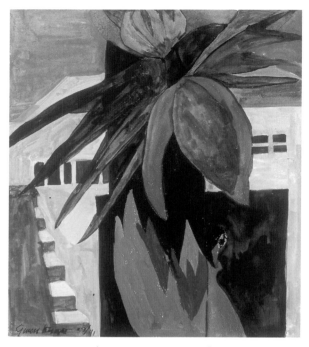

Fig. 3. **UNTITLED (NEW ORLEANS SERIES)**
1941, gouache on paper, 14½ × 12¾ inches

Jake's distant relatives. The pace of life slowed to a quiet crawl. Spring brought the dogwoods to full bloom and the fragrance of flowers filled the air. The living was more rustic than in New Orleans. They had a room where they lived and painted. They prepared their own food and shared the outhouse. It was a revealing time. They encountered people who appeared to know little or nothing about history or the socially progressive movements going on in the cities. "They were suspicious of us. They were sure we were doing pictures of them to send away to New York. This frightened them. They were afraid that we might be communists."

There was no social life to speak of. Their hostess was not "of the church," as Gwen puts it. She kept what was referred to as a "tea room." "Every week she would kill some chickens and fry them. Then she would make some 'home brew.' She had a jukebox that played music in the parlor. People would come to eat and dance. They did this every week."

The two city kids returned to New York, where they rented an apartment in Harlem, but by the summer of 1942 they were employed in New Jersey as camp counselors for the Workers' Children's Camp. Gwen assisted in the camp's art classes for the next eight to ten weeks. There were overnight hikes followed by early morning reveille. "It wasn't a bad experience. But there seemed to be a lot of horns tooting. Horns to wake up and horns to go to bed. And the camping—I am definitely not a camper!"

During this period, Gwen's foster family moved from Harlem to Brooklyn's Bedford-Stuyvesant neighborhood. With the slow decline of Harlem during the Depression, owing in part to the exodus of the middle class, the neighborhood's economic base had weakened. Their apartment, like Harlem, had seen its best days. In 1943 Gwen and Jake followed the family, finding a place only a few blocks away. In their two-bedroom apartment, they established a familiar scene: Jake took one of the bedrooms for a studio, and Gwen used space in the living room. "I could sit down in the midst of chaos and do my painting." Jacob was mystified by her ability to block out the clutter of her surroundings and make art.

This was also the year that Jacob was called to active duty in the Coast Guard. His home port during World War II was Boston. Between his leaves and her trips up to Boston to see him, Gwen painted. For company there were Thomas and Jane, their two cats, and her family, who were close at hand. The idea of communism was rampant, she recalls. Cooperatives of various sorts sprang up all around. She taught for a stretch at a cooperative-style school for young boys. There were lots of calls to organize this and that, but Gwen was essentially apolitical. "I didn't join anything really. Communism seemed like yet another set of rules to follow. There were people to follow and people in charge, just like where I was. I didn't see the point in it."

Discharged in 1945, Jacob returned home to resume his teaching and painting career. Even in the armed services, the light from the power of his work never dimmed. Gwen con-

tinued her painting, but she was ever supportive of Jacob's work and his involvement in a flurry of exhibition activity. In 1946, at the invitation of Josef Albers, Gwen accompanied Jacob to Black Mountain College in Asheville, North Carolina, where Jacob would teach. To avoid segregation on the train, they were transported in a private car to and from Asheville, and during their ten-week stay at the college, Gwen and Jacob never left campus. Professor Albers and Black Mountain College, by their invitation, had defied the prevailing racial sentiments, and Gwen and Jacob, by their acceptance, had asserted their right to be there. The campus setting was idyllic with lots going on. There were seminars in music, dance, and visual arts. Gwen, though not an official instructor, shared her knowledge of the Martha Graham dance technique with the students and dance faculty. She recalls only one person in the program who seemed negative about their being there. The rest of the faculty was supportive and hospitable.

In 1949 Jacob suffered severe bouts of depression that required his hospitalization off and on for the next two years. Gwen, aided by gallery owner Edith Halpert, found a job at Condé Nast Publications, where she worked in the library and magazine archives. Certainly this was a good way to earn a livelihood, and, as with most of the changes in her life, Gwen approached the job as an exciting learning experience. As a painter, she'd not worked much with the concepts of pure graphic design. Knowing she needed to be prepared to help earn their living, she enrolled at The New School of Social Research to study with one of the chief designers of the magazine, Alexei Brodovitch, who had created the "field of design" and thereby influenced a whole generation of photographers, including Richard Avedon and Irving Penn. He was at the helm of *Harper's Magazine* from 1934 to 1958. In his classes, Gwen found a new language and new ways to think about the world. She worked at Condé Nast for over a decade, while Jacob, who had regained his health, resumed with full vigor his teaching and painting schedule. In 1964 Condé Nast offered Gwen a position as secretary in the art department,

a good offer for the time, but by then both Jacob and Gwen had set their sights on Africa.

Before going to Nigeria in 1964, they sold their co-op apartment in Brooklyn, which had been purchased with help from Gwen's family in 1957. They had bought it through a program designed to assist middle-income people obtain their first home. Though they were both working and Jake's paintings were selling, Gwen thought it a stretch to call them middle-income earners. It was a new building in 1957, and the Lawrences had never before lived in racially integrated housing. The enterprise of constructing racially mixed dwellings was strongly supported by Eleanor Roosevelt. As a proponent of this co-op project, Mrs. Roosevelt was invited to a dinner in the complex, which Gwen and Jacob also attended. "She was an elegant woman. And she lived her ideals. We enjoyed meeting her."

Gwen's foster mother died in 1958, just about the time the Civil Rights movement was heating up and sending great waves across the country. Talk of public school desegregation was rife. The cold war and the race for space were on. With the president's assassination in 1963, John F. Kennedy entered American mythology and his picture found an honored place in homes all across black America, alongside the likenesses of Jesus Christ and the Reverend Martin Luther King Jr. The Beatles hit American shores in 1964, and American youth grew their hair straight down or up and out. Clothes went paisley and plaid, and bell-bottoms became de rigueur. The world was heading psychedelic at about the same time Gwen and Jacob finally obtained their passports to Nigeria, with difficulty because of Gwen's Barbadian birth. The United States at the time they left was in an uproar, awkwardly breaking out of its shell, trying to live up to its own ideals.

They traveled to Nigeria as they had decades earlier to New Orleans and Virginia—to feed their imaginations and to give life to what they had only heard about. Because they arrived in Lagos as private citizens and not as a part of a government exchange program, they were received with suspicion. There was talk of their being communists, come to proselytize

and make converts, and they were kept in a state of limbo, unable to obtain housing. The American Consulate was unsupportive. At one point Gwen became enraged. "I was so angry," she says, "that I raised my voice and I was not very polite. I told them that we were citizens of the United States, and that my husband had served in the war! I told them that as soon as we got back to the United States, we were going to call the ACLU and sue them. The Africans and many of the others in the room were surprised to hear anyone speak to officials like that."

After they had threatened to leave the country and return to the United States, things started to shake loose. They were finally encouraged to stay and were given a maisonette that was sponsored by one of the resident oil companies. "It was a lovely space with a half-moon entryway. We stayed there for a time and then moved on to Ibadan, Nigeria. There we rented an apartment from a local African woman. There, in all that heat, her house was filled with European furniture—things like large, overstuffed couches and fancy wooden tables. It was amazing. She asked Jake and me how we were planning to furnish our apartment. When we didn't answer right away, she gave us a couple of things. That was nice, but soon we went to the market and got cots for sleeping. We bought things the Africans were selling and using in their homes. We even bought a cot for our houseboy. Our landlady was baffled by that."

In Africa, everyone seemed to have servants or houseboys, usually two—a big houseboy and a small houseboy. What signified "big" or "small" remained a mystery, but theirs was a small houseboy named Sylvester. "He helped us with shopping and showed us how to get around. We were immersed in the culture. There were no phones. We got along on very little. Jake and I both painted and exhibited our work through the American Society of African Culture. It was hot, but every evening at just about five o'clock it would rain and cool things off." They ventured out to the markets and met the people of Ibadan. These were unremarkable events that yielded remarkable work and experience.

In 1965 they returned to the United States via Italy. After eighteen months away they were back walking down 57th Street in New York, and the sheer volume of things they encountered shocked them. "We said to ourselves, this is excessive. What do people do with all this stuff!" And indeed, Gwen and Jacob's living spaces throughout their lives have been spare by American standards. They surrounded themselves with a few choice items: a sculpture by Augusta Savage, a few African sculptures, and a limited selection of each other's work. They bought a television set in 1963, still in use some forty years later. Their stereo was and still is a "hi-fi" with a turntable record player. Clothes have always been repaired, not discarded. Even their studios were spare. Jacob collected tools but his space was never cluttered. Gwen's space was less ordered but the actual objects were few.

Still nomadic even after their return to the United States, Gwen and Jake moved for a time to Boston, where Jacob, after being appointed a member of the Academy of Arts and Letters, took a position at Brandeis University. In Cambridge, they rented living space from a white woman who openly, in defiance of the time, let to people of color. And hers was not just any home. She lived on Brattle Street in one of Boston's most prestigious neighborhoods. Brattle Street had housed George Washington's military headquarters in 1776, and it was on this street that John Adams, Thomas Jefferson, and other members of the Continental Congress had met to set the course of America's independence.

Ironically, with all the high-profile civil rights protests, sit-ins, and boycotts, Gwen and Jacob's quiet crossing of this barrier went unnoticed, but it was yet another line over which they had stepped. It couldn't have been easy every day to be a part of one homeowner's small protest against a staunchly divided city. But they knew what they were doing. Gwen laughingly referred to their landlady as the "neo-abolitionist." They joined in her challenge, nonetheless, just as they had during the 1940s, when they set out for Black Mountain College.

Like homing pigeons, Gwen and Jacob returned to New York in 1965. They found a great apartment on the Upper West Side, between Broadway and Amsterdam. Again, it served as home and studio. Although Gwen continued to paint, she had rarely exhibited save for one group show in Hempstead, Long Island, in 1961. In the summer of 1967, her work was included in a group show alongside that of Jacob, Benny Andrews, Raymond Saunders, and a number of other well-known artists of the period.

At the New School, Gwen took classes taught by Anthony Toney, with whom she had studied prior to leaving for Africa. "He provided a wonderful background for a painter. I would always paint out of myself, depending on my own emotional response to the subject. But he would explain and demonstrate the basic elements necessary to bring to every painting. He showed us how to deal with color, space, and form. He was a great teacher, and a very good artist, but oddly enough he never gained a great reputation for his own work."

Aside from her classes at the New School, she and a group of fellow women painters joined together to discuss their work and go to museums and galleries. Her work from the 1960s includes a number of closely studied portraits. There is an irresistible portrait of Jacob started in 1960 (and later retouched for exhibition in the mid-1980s) that demonstrates her skill and the emotionality she brings to her subject matter. Jacob smiles out from the canvas with a warmth in his eyes that catches and holds the viewer. She demonstrates an economy of strokes, an impressionistic likeness created with seeming ease.

Gwen first traveled to Seattle with Jacob in the spring of 1970, where he, at the invitation of Professor Spencer Mosely, taught for a quarter at the University of Washington School of Art. In 1971 he was offered a tenured position. Though they expected to be in Seattle for no more than four or five years, they rented for a while, then bought a house in Laurelhurst, a neighborhood just northeast of the university. Former apartment dwellers who had never owned a car or learned to drive, they found themselves living in a city built around the

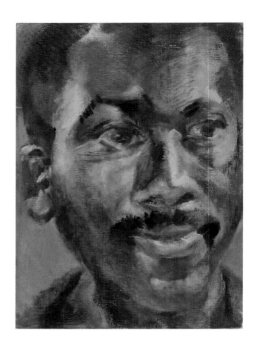

Fig. 4. JACOB, 1986,
oil on canvas,
14 × 10 inches

formal figure drawing, she and some other artists hired a model and formed a group that met monthly. In addition, she joined life-sculpture sessions with artist Everett DuPen.

By the mid-1970s Gwen was an active member of Seattle's cultural community. She sat on the King County Arts Commission and the Seattle Urban League. A friend and fellow League member, P. Raaze Garrison, worked with Gwen on the Urban League's annual exhibit. She was struck by Gwen's knowledge of art and how she worked with the other jurors who had far less arts experience than she. "I noticed how she talked to the other jurors, how she explained the artworks and why she felt some were above or below the mark they were looking for. She taught while she spoke. She had a quiet strength. She didn't waste words, and people listened to her."

At the university, Jacob was befriended by Michael Spafford, a colleague and fellow painter, who introduced him to gallery owner Francine Seders. Francine represented a number of the University of Washington art faculty. During a conversation in the mid-1970s with Francine, Jacob mentioned that his wife, Gwen Knight, was also a painter. This was news to Francine and a little-known fact to most in Seattle who had met Gwen. Francine visited Gwen's studio and liked what she saw. On that visit Gwen didn't talk about her work or introduce it in any way. She simply said, "There it is." Francine's first impression was that it was a traditional kind of work that served no artistic trend: "That's what I liked about it. The work was true to itself. Gwen likes people. She likes doing portraits of interesting faces. I'm always struck that her portraits look like someone you know. There are two reasons to buy a portrait—either it's someone you know, or the face is interesting and it's got a quality that holds you. Gwen is able to do both."

Knight's first solo exhibit in Seattle was at the Seattle Art Museum in 1976, sponsored by the Seattle Chapter of Links, a black women's philanthropic organization. This was followed in 1977 by her inclusion in a group exhibit of figurative work at the Francine Seders Gallery, which now represented her. At age sixty-three, Gwen was at a point in her career when most

automobile. They walked or rode the bus nearly everywhere they went. Gwen took on Seattle as she had approached her travels with Jacob to New Orleans, Lenexa, and Ibadan. It was a new place, another adventure in living.

Their house, a late-1940s wood-frame structure, stood on a corner lot surrounded by grass and shrubs. They worried that it had too many doors and windows. They were unaccustomed to the creaks and groans of a house constantly settling. The house's nighttime mutterings startled them awake when set against the quiet of a Seattle neighborhood devoid of the street-life night sounds so familiar to them. Even the daily air around them, the quality of the light with its gray prismatic filtering of color, required an adjustment. Amidst all the newness, they set up their studios. Jacob took the small attic space that was up a narrow flight of stairs from the main floor, and Gwen settled into a converted space just off the garage, which she would eventually trade for a space a mile or so from their house. In her new space, she reworked ideas from her older paintings, and for new source material she found sitters with interesting faces. For fellowship and an opportunity for

artists' debut exhibitions would have long been behind them or the idea discarded altogether. But her exhibition history, like her life, was not on a traditional trajectory. Since the mid-1970s, Gwen's work has gained an audience and recognition in the Northwest and beyond, with exhibits in venues including Georgia, Oregon, and Washington, D.C. But even in this she keeps to her tradition. She is not a lecturer on her work, nor does she try to sell her ideas in public presentation. The viewer is invited to look and see what she has given. Her reasons for painting are many. She says, if asked, that she works from an emotional response to her subject matter, and with this response she brings a concern for composition, line, color, and value.

In the late 1990s, at the suggestion of artist Elizabeth Spafford, Gwen tried her hand at monoprints. Elizabeth thought she would like the medium. Liz inked up plates, which Gwen then drew into. She had to work fast and loose. She liked to have live subjects as models, so if the cats were walking around, she drew the cats. She loved movement, so she improvised dancers on her plate and found this to be a perfect medium for her. Michael Spafford watched her take to the medium with delight. "With monoprinting, there is the gestalt of recognition," he says. "Once it's done, it's like being confronted with one's self in reverse. Gwen was able to bring all the information she had to bear on the subject, but without thinking."

Mike Spafford observed that Gwen's approach to working was: "the more she could learn the better she could do." This has been a theme in her life from the time she returned to Harlem from Howard University in Washington, D.C., to join the Augusta Savage studio, to her tenure at Condé Nast and her classes with Brodovitch at the New School of Social Research, to her studies in the 1960s with Anthony Toney. Making the art has been the point of Gwen's artistic life, and if there were to be exhibits and a career out of it, so be it. It's the purest idea of being an artist, and it's not at all surprising that Gwen, coming from her generation, should hold to this ideal. This statement sounds strangely out of step with today's world of ambition, with our contemporary sense of what drives an artist and what is success. To be an artist in her time, when recognition and exhibition opportunities for artists of color were rare, and when being a female was more of a liability than it is today, the only thing over which she always had power was her art itself and her belief in it.

Gwen first returned to Barbados in 1973. As she stepped from the plane, fifty-three years slipped away as if they were nothing. The heat, the ocean breezes mixed with flowers and sweat, and she was home again. Her mother, Miriam, now eighty, was still there. Though they'd corresponded frequently and had exchanged telephone calls, keeping in touch through the years, Miriam did not travel and she knew few details of her daughter's artistic life. But she knew that her daughter had done well for herself in the United States. Of her mother, Gwen says, "She wanted me to be a teacher or a government worker, something like that. Those were the kinds of things she understood. My being an artist—that life—was not something familiar to her. So we didn't talk about it. She loved Jacob. And she was happy for me."

Gwen's fifty-nine-year marriage to Jacob was interrupted by his death on June 6, 2000. Being his partner was an early choice and a major endeavor she had openly embraced. In her marriage, as with her painting, she never faltered nor felt her light diminished. Gwen is fierce. Her fierceness was easily discerned in Nigeria when she confronted a nonsupportive American government; it was there in her ability to change worlds on a dime, or to drop down in the middle of the chaos of her living room or the sweltering heat of another country to paint; it was there as she crossed historical and racial barriers in North Carolina and Boston, all the while taking life on as an adventure.

In Gwen there is no false modesty. Those looking for a crack in her façade or for any bitterness will not find it. She says without regret, "I am always pleased when someone likes my work or if they want to give me an exhibit, but I've never depended on the support of outside forces to make me an artist."

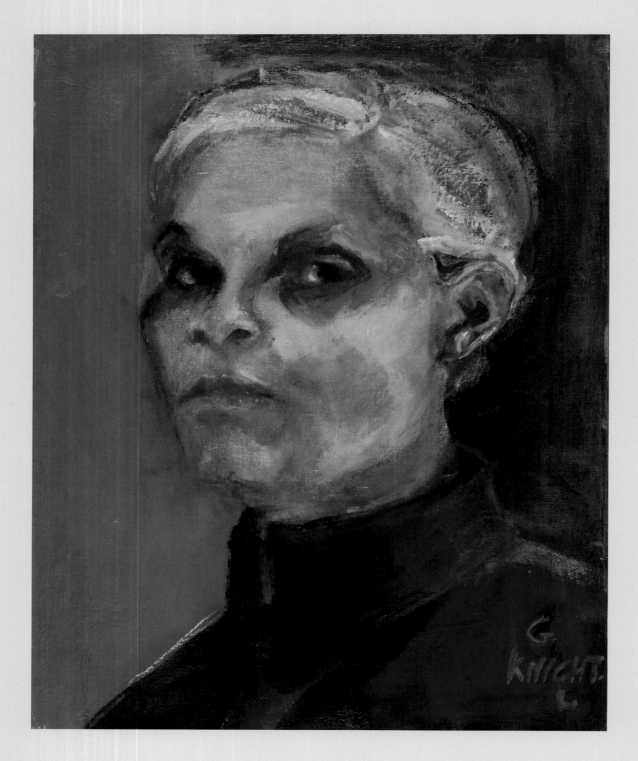

PORTRAIT OF THE ARTIST
1991, oil on canvas, 20 × 16 inches

SHERYL CONKELTON

Gwendolyn Knight: A Life in Art

The first images Gwendolyn Knight remembers making were portraits. She was about eight years old, and these pictures precociously foretold her enduring artistic interest in people. Her career spans more than sixty years, from her earliest professional work in the Harlem studio of Augusta Savage and the WPA mural workshop run by Charles Alston, to her recent immersion, since the mid-1990s, in printmaking techniques, including silkscreen and monoprints. Throughout this lifetime of work she has consistently pursued her interest in portraiture and figuration, bypassing successive movements of abstraction, expressionism, conceptualism, and political art, while maintaining her art in close connection with her own life. Knight's images are not a polemical record of a historical era, nor are they anxiously ambitious in their artistic reach; they simply and quietly render in paint what occupies the artist's mind. They are made to satisfy the artist in her own explorations, and it is the artist's openness to experience and learning as well as the modest intimacy of the works that are part of their great appeal to viewers.

Knight does not remember deciding to be an artist, but she recalls being inspired as a child by a calendar illustration that contained brilliant reds and greens.[1] Color plays an important role in her paintings: active and sensuous, it establishes pictorial power. Her color is autonomous at times, working not to describe form but to animate it, separating expression from depiction and memory from observation. Knight references real subjects and has often painted from life, but the majority of her works take great license: she will pump up a yellow to vivid wattage, allow the deep-colored stripes on a dress to define a composition, set saturated hues in counterpoint to render complementary brilliance from the colors of a simple still life.

Central to her art is the role of her own experiences. Her childhood is a happy remembrance, even though while still young she moved with her foster family to the United States from her native Barbados. Her youthful artistic enterprises most often involved performance; dancing and singing

were favorite activities. She grew up in a secure household, first in St. Louis, Missouri, and then, as she attended high school, in New York's Harlem, in middle-class black neighborhoods that provided a strong sense of community. Knight was a voracious reader who also loved theater; she was inspired by good stories and deeply felt emotions. She remembers being comfortable in her various artistic experimentations, though not particularly encouraged to follow art.[2] Her tastes were catholic: she loved Shakespeare, opera, Kurt Weill, Gustav Mahler, and jazz, and she and her friends went to performances and talked animatedly about what they had seen and heard. The arts provided an intensely social and exciting arena for the formulation of her ideas, and it seemed simply natural that she should pursue these interests at college.

After high school, Knight enrolled at Howard University in Washington, D.C., where she studied from 1931 to 1933. She took classes with Lois Mailou Jones, a young painter who had studied at the Rhode Island School of Design and had designed costumes for the modern dancer Ted Shawn. Jones's work was very design oriented, incorporating abstract elements from Haitian art. She painted images based on masks, a natural subject given her interest in costume, but also attributable, in part, to a keen interest in her African origins.[3] Jones's early works, made prior to her receiving a Julius Rosenwald Fellowship which supported a trip to Paris in 1937 to study, were similar to Post-Impressionist landscapes: familiar scenes that were obviously interpreted but still recognizable as real places. Jones also painted figures and portraits; these works were similar to the subjects and kinds of interpretation Knight would try. Jones taught design and emphasized composition in her classes. Knight recalls designing posters as a means of learning various ways to compose images. Although much of Jones's imagery, as well as her commitment to the depiction of real subjects, would be found later in Knight's own work, Knight remembers Jones simply as being encouraging rather than strongly influential.

Knight also studied with other teachers at Howard. One of the most important figures for her was James Lesesne Wells,

a printmaker who looked carefully at German Expressionism as well as African art.[4] Wells's graphic boldness was admired and supported by Alain Locke, the head of Howard's philosophy department and a major force in the New Negro Movement. Promoting "a vigorous and intimate documentation of Negro life itself," Locke actively championed the works of artists he felt fulfilled this mission, and he wrote a number of important and influential books and articles, among them *The New Negro* (1925) and *Negro Art: Past and Present* (1936). He particularly advocated the study of African art, encouraging artists to incorporate its forms into their work as a means of manifesting and portraying the significance of "cultural pluralism": "there is the possibility that the sensitive artistic mind of the American Negro, stimulated by a cultural pride and interest, will receive from African art a profound and galvanizing influence."[5]

Wells, in turn, was supportive of Knight's efforts. She remembers him with fondness, though apparently not for any specific advice or criticism. She wasn't so interested in graphic arts at that time, and Wells's emphasis on printmaking did not have a strong impact on her development. No work from her early college efforts survives, but the experience of Howard, with its intellectually charged environment and interactions of literature, art, and critical thinking, provided opportunity for Knight to contemplate her ideas about modern art and its expressive potential in the midst of a richly debated culture. Unfortunately, the Depression forced her to leave Howard and return home to Harlem after only two years. The powerful ideas of African American self-reflection and self-realization circulating at Howard would appear not to have been directly influential on the young Knight. She recalls nothing from this time with passion, although the strong rhetoric of Locke, Wells, and others would certainly have reinforced her burgeoning sense of self and the idea that art could be a realization of self as well as its expression.

In Harlem, Knight gravitated toward intellectual and bohemian circles. Her years of voracious reading prepared

her well for the heady atmosphere of Harlem's renaissance of literature, art, and politics. She had read modern literature even as a high school student, making great use of a second-hand bookstore around the corner from her apartment, and had read William Faulkner before she went to college. Now, in addition to Harlem Renaissance writers such as Countee Cullen and Zora Neale Hurston, she was reading Virginia Woolf, particularly taken by her *A Room of One's Own.* She remembers reading Radclyffe Hall's *The Well of Loneliness,* a 1928 novel about a lesbian couple which had been banned in Great Britain, as well as the 1931 English translation of Rainer Maria Rilke's *The Notebooks of Malte Laurids Brigge,* the story of a young writer's life in Paris and a novel that prefigured existentialist writing. "Reading excited me because . . . I developed these visual sorts of images and this emotional sort of involvement with the characters in the books."[6] In addition, she read magazines and recalls clipping articles about writers and artists as well as fiction from *Vogue.*

A friend told her about the arts workshop run by the sculptor Augusta Savage in a renovated garage in the neighborhood; Knight went immediately to investigate and began to attend every day.[7] Savage had opened the Savage Studio of Arts and Crafts in 1932 at 163 West 143rd Street, where she offered instruction in drawing, painting, clay, and woodworking. Knight took classes in painting and sculpture with Savage from 1933 until 1937, when Savage became director of the Harlem Community Art Center.[8] Savage, along with other painters such as Richmond Barthé and Sargent Johnson, produced images that promoted African culture as a modern alternative to that of Europe, and emphasized sensuality and emotional content.[9] She was an influential teacher, and one of her main accomplishments was her instruction and encouragement of the next generation of artists, among them Norman Lewis and Ernest Crichlow. In addition, Savage founded and directed the Vanguard Club, a weekly forum for discussion about the arts, and later, in 1939, she ran a gallery on 125th Street, The Salon of Contemporary Negro Art, where

Knight and many others showed their work. Knight has said of Savage: ". . . she was my mentor. She was a second mother to me and to me her studio was a second home. . . . By looking at her I understood that I could be an artist if I wanted to be."[10] Savage's workshop, in addition to being an art school, was a meeting place for the arts community in Harlem; there were exhibitions, lectures, and readings. Knight became friends with many other artists there, including the painter Georgette Seabrooks, a portraitist who emphasized her African American heritage, and the sculptor Selma Burke, another portraitist, whose later depiction of Franklin D. Roosevelt would provide the image for the design of the U.S. dime.[11]

Art classes were also held at the 135th Street New York Public Library and later in Charles Alston's studio at 306 West 141st Street, both funded by a federal government program, the Works Progress Administration (WPA). Savage, Alston, Henry Bannarn, and James Lesesne Wells were some of the teachers. Notable writers and activists such as Alain Locke, Langston Hughes, Ralph Ellison, and Claude McKay lectured there, as well as the artists Aaron Douglas and Romare Bearden, all of whom emphasized cultural identity and black achievement. Knight does not recall being convinced or influenced in her own ideas and art by the debates and conversations, but she recognizes that the intellectual and creative ferment permeated her milieu: "It was in the air."

Knight went to work for the Works Progress Administration's Fine Arts Project (FAP), a federal program during the 1930s' Great Depression that organized work for artists and paid them for their labor. Artists often contributed to public works; government buildings such as post offices were commonly the sites for FAP programs, although artists were also paid to teach other artists in studios and workshops. In addition to providing employment for the artists, the FAP was also intended to influence public morale by creating works that would foster patriotism with their imagery. Knight assisted on a mural at Harlem Hospital, where Charles Alston ran the project. Alston had studied in Alain Locke's personal library

and had absorbed some of the ideas of the New Negro Movement as well as the imagery of African art. Alston was the first African American supervisor of an FAP division, and, assisted by Beauford Delaney, he designed the major mural and oversaw the other projects at Harlem Hospital (there were seven separate mural projects). His own pendant murals, *Magic and Medicine* and *Modern Medicine,* were controversial, both for their depiction of an African medicine man and their mixing of races in the portrayal of a modern hospital scene, but they were finally approved.[12] They were exhibited at the Museum of Modern Art in 1937 and were then installed at the hospital.

Knight never worked directly with Alston. She was an artists' assistant on other murals for the children's ward in the hospital, helping to prep the walls and making sketches for the preliminary proposals. She did not paint the murals themselves. She worked with a team of artists making drawings to conceptualize the designs, which consisted of fantasy imagery loosely based on fairy tales; there were also simple decorative schemes that depicted toys. The whimsical images were meant to distract the sick children from the difficult reality of their own interrupted lives, offering playful figures of children, birds, and animals, such as a stork delivering a baby, and the "little old woman who lived in a shoe."

Knight characterizes herself then as being apolitical and does not credit any one of the many artists she met with specifically influencing her own artistic ideas. Instead, she talks about the pervasive vitality of those times. The overtly political motivations of the WPA generation were not hers; she was concerned with the world of artists and dancers and with finding her own way in the midst of a myriad of styles and modes of expression. So much was readily available to her: Aaron Douglas's simplification of form and his powerful visual rhythms, evocative of music, were prominently visible in the murals, *Aspects of Negro Life,* installed at the 135th Street branch of the New York Public Library in 1934; the silhouetted and elongated figures of Richmond Barthé, who was interested in and produced a series of monumental reliefs for the Harlem

River Housing Project in 1937; the controversial Harlem Hospital mural narratives by Alston. She deliberately and carefully weighed the impact of works by other artists, but she maintained her own particular subjects and treatments, constructing her own vision during what was a time not only of great opportunity but also of great artistic pressure. She has said of the period: "It was a vital time, and if it had not been for the rich environment, I would not have created as I did."[13]

Knight met Jacob Lawrence in 1934 at Alston's studio at 306. He was younger than she, was very serious about his work, and had already been recognized as particularly talented by Alston and others. With money he received from a Julius Rosenwald Foundation grant, he rented studio space from Alston. Soon Lawrence and Knight were working together; she helped gesso the panels for his *Migration of the Negro* series. Even in this early relationship, there were strong differences in their art and their ideas and the ways in which they chose to work. Lawrence planned everything in advance in his paintings; all of the images were conceived and composed before he started painting the first panel. He was very committed to the painted image as a means of making history known. Knight did not work that way: she did not plan, and history seemed, in some ways, an impersonal project for her. She remained interested in her own spontaneous responses to things, and in the energy generated by responding in the moment. Together they socialized with other artists, going to shows and visiting museums, and having long discussions afterwards.[14]

Knight's earliest surviving painting, *Portrait of a Girl* (cover image and page 40), shows the head and shoulders of a young girl set against a window opening onto a simple landscape. Painted probably in 1940, it is a small image, executed in oil on canvas. Its touches of brilliant red match a bold flower just outside the window to the girl's lips, just as the warm pink collar of her dress echoes the same hue in a flower on the wallpaper. The heavy, blue-shadowed eyelids are the colors of the walls; the bodice of the dress is painted in a green with a value very close to that of the blue of the interior. The shapes are

very simple, with curving and sinuous edges. The girl's hair—a raven, blue-inflected black—has a bouncy, waved edge to it. The jewel-like, unmodulated colors lock together in a pattern on the surface. The restricted color palette creates a relationship between the girl and her environment; her flounced collar resembles a flower and doubles the connection. The repetition of significant forms and colors was practiced by a number of American modernists, from Richmond Barthé to Arthur Dove. They set up visual rhythms that reference natural forms and establish an evocative equivalence of figure to nature. Knight makes use of similar devices in *Portrait of a Girl;* its deceptive simplicity is an early illustration of the means that would dominate her mature practice.

Almost all of Knight's early works have generic titles: *Park, Interior, Tea Room, Bayou.* In each, some element—strong line, brilliant color, odd form, or odd perspective—informs the sense of place, but each remains subtly imaginary. This is due, in part, to the strong, reductive compositions and simplified shapes that Knight consistently composed. Colors describe shapes rather than forms, reinforcing the sense of flatness. The images are very much abstractions from her observations rather than closely rendered realist depictions. Although there are always some details that capture some specificity of place or light and communicate a sense of presence, the painted scenes seem imagined, reduced to their essence perhaps through recollected memory. They are not realistically or directly presented; they are interpretations, distillations, concentrated essences. Knight subtly maintains a distance from the details of her own life, and many of her paintings contain a kind of nonspecific and universal imagery that evokes an emotional recognition.

Knight and Lawrence were married in July of 1941, and soon afterwards they traveled to New Orleans to fulfill a grant Lawrence had been awarded to explore rural and urban communities in the South. They lived on Bienville Avenue, and both painted there, working in gouache. Knight chose to paint familiar objects and scenes in the local neighborhood.

She continued to work with shapes rather than with drawn lines, employing her color to create interlocking blocks of color. Here her hues became much brighter, clearer, and more pure: reds, yellows, and blues worked in tandem with bright whites to portray a sunlit place. Knight kept her shapes simple: paintings such as *New Orleans, Scene I (Back Porch)* (page 43) and *New Orleans, Scene II (Store)* (fig. 1) have a naïve character, somewhat akin to Lawrence's simplifying style and deliberately awkward drawing, although Knight's paintings are less spatially complicated. The scenes are quotidian, representing incidental, in-between moments. Nothing happens, but the details reveal sharp observation of the physicality of this new environment. Although the shapes are simply rendered, carefully considered elements convey immediacy and a sense of trueness, such as the white heat that draws up the sky's blue, and the different colors of dark skin on the two figures.

Knight also made some paintings that are darker and more sensual, including *Bayou* (page 41) and *Blossom* (fig. 2). Each of these transforms the forms and colors of New Orleans into a seductive image. The central tree in *Bayou* is hung with gray-green Spanish moss that seems to entwine with the patches of blue sky behind it, and the green river undulating by at its feet is edged in deep red. The deep thalo blues and greens of *Blossom* are rent by a swell of crimson fruit and a thin line of bright yellow light that penetrates the leaves from behind. The compositions, built simply from the layering of related blues and greens, are punctuated with hot color. Both paintings, as well as that of an untitled 1941 gouache of a banana flower (page 42), show Knight experimenting with natural forms, exploring the idea of significant form, and isolating and enhancing those visual characteristics that are capable of effecting a seduction. Her time in the South had a strong impact; she loved its sultriness, which reminded her of Barbados, and she was able to conjure the intensity even after she returned to New York: *Bayou,* for example, was painted after her return home.

Another early painting, *Interior* (page 44), was done while Knight and Lawrence visited his family in Virginia, following

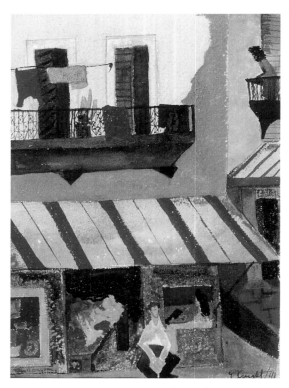

Fig. 1. **NEW ORLEANS, SCENE II (STORE)**, 1941,
gouache on paper, 9 × 6¼ inches

their stay in New Orleans. Also small, it is an intimist's view
and depicts a corner with a chair, a robe or coat hung close to
a stove, and other pieces of clothing draped casually over the
chair's back and arm. This painting was done in gouache on
board, and Knight used the paint's qualities to advantage:
the translucency of the watered paint allowed her to depict the
folds of the hanging cloths without outlining by simply over-
lapping her strokes, while the slats of the mission-style chair
and the squat silhouette of the stove and chimney pipe were
painted a deep, flat black. In fact, the chair and stove cohere
visually as a single shape, an abstraction that enlivens the image
and demonstrates Knight's interest in the two-dimensional
design of her paintings.

Knight and Lawrence settled in Brooklyn. They painted
separately, working alone and in privacy. Lawrence began

another major narrative series, this time based on the life
of John Brown. Knight continued to paint her immediate
surroundings, manifesting a new level of detail and a more
complicated sense of composition. Works such as *Horse and Cart*
and *Park* (pages 46 and 51) display some new experimentation.
Each of the subjects is depicted as if seen from above, and the
figures are more stick-like than in earlier works. In *Park,* a
number of ordinary activities take place: children sail a small
boat, others skate or play ball; a woman walks a baby carriage,
and other adults sit on a bench. The lines of the figures ges-
ture rather than describe. The emphatic curve of the pathway
and its echo in the bowed edge of the fountain create a design
that is more than figurative line: now the entire composition
is animated in an abstract way and encompasses a mature
manipulation of space, rather than being organized by lines
or shapes.

The same kind of awareness of composition is evident in
Horse and Cart. In this image the street opens up a blue wedge in
the yellow of the picture plane. The wagon is seen from above
and the side in a deliberately naïve configuration of perspec-
tives, and the touches of white that indicate rain cover the whole
in a soft patterning. The overall sense of extreme flatness and
the precipitous tilt of the ground render this painting rather
unusual in Knight's oeuvre. Much more than any immediacy,
the viewer is struck by the modernist composition that rele-
gates the subject to a secondary position—highly unusual for
Knight, but a provocative experimentation. It is very possible
that Knight was interested in exploring the complicated,
cubist space that Lawrence constructed in his paintings. He
was very committed to artistic invention; Knight seemed less
engaged with it, her interest rooted in the emotions poten-
tially manifest in her interpretation rather than in artistic
bravado.

Knight soon returned to more iconic and sensuous imag-
ery. When Lawrence was away for more than two years on a
U.S. Coast Guard assignment, from the fall of 1943 to the end
of 1945, she settled into her life, and worked and painted. A

few pieces survive from this productive period, including two early portraits of cabaret types, *Mask* and *Café Singer* (pages 47 and 49), both from 1945. These are relatively dark paintings, and neither conveys the sense of a real individual. In *Mask*, which Knight had first titled *Comedian,* the man's baleful eyes and red, downturned mouth communicate an archetypal sadness, despite the crown of energetic yellow strokes that indicate a brimmed hat on his head. This is not a portrait of an individual but a symbolization of the vaudeville performer; Knight's changing of the title makes this even more apparent. The picture is not unlike the generic "blackface" images that appeared in contemporary advertising; it is perhaps a comment on the individual-obliterating effect of such imagery, and it is unusual to see this possibly political thrust in Knight's otherwise apolitical work. The woman portrayed in *Café Singer* has much the same kind of dramatic visual presentation, although it is more subtly expressive; indeed, it is difficult

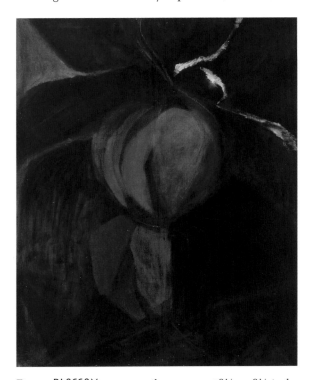

Fig. 2. **BLOSSOM**, c. 1941, oil on canvas, 48½ × 38½ inches

to discern what emotion is signaled. The eyes are strangely droopy and focused on some distant subject. The deep red contrasts with the deep yellow-green, creating a hoodlike effect that might be a scarf or the woman's hair. Knight uses every effect to detach the singer from our space, to disconnect her from our rapport. It is another sad picture, but it is difficult to discern whether the sadness is the expression of a song or of the woman's situation. Knight did intend the image to represent the cabaret performer's loneliness, but even in her own description, the sadness of the song and the sadness of the performer cannot be disentangled.

Paintings such as *The Boudoir* and *Girl in Armchair* (pages 48 and 50), made about the same period, echo earlier works with their rich hues and iconic imagery. Curvaceous lines and interlocking colors contribute to a visual lushness and draw connections between natural and human forms. Considered together, these two images create an odd confrontation of archetypes, a sense of their pendancy enhanced by the similarity of their compositions, both of which incorporate tilted, circular bases. *The Boudoir,* 1945, is an aggressive image: a female figure sits upon a lavender pouf, her angular pose and yellow body contrasting with its soft form. A green drape hangs behind, and scattered in different places are depictions of small plants or fruits. The image is curiously reminiscent of certain late-nineteenth-century Symbolist paintings, from its juxtaposition of acid colors to the unusual pose of the nude and the ferocity of her luridly made-up expression, but it also has significant contemporary counterparts in images by painters such as Eldier Cortor and Aaron Douglas. The reductive, caricatural nature of the central figure can also be related to elemental constructions of African personae, such as Josephine Baker's extroverted vaudeville. *Girl in Armchair,* c. 1950, returns to Knight's gentler, more lyrical abstracting style and familiar domesticity. It shows a woman in a peach dress, enveloped in a comfortable armchair, settled smilingly into the black cavern between its green wings. Knight's color strategy, with its reliance on secondary colors and complementary combinations,

is now familiar and apparent in the juxtaposition of pink-orange and blue-green complements. Again, the shapes interlock without need of defining lines. It is this kind of imagery, with its familiar *topos,* that Knight would continue to prefer—gently evocative, domestically themed and scaled, reassuring in its subject and treatment.

These early images reveal some affinity in Knight's practice with that of early modernists who were interested in painted equivalents for their emotional experiences, such as Arthur Dove and Georgia O'Keeffe, both of whom were favorites of Knight. Although surrounded by advocates for various kinds of pictorial renovation of African and African American history and culture, Knight persisted in pursuing a less narrative idiom. She and Lawrence often visited Alfred Stieglitz's An American Place gallery in New York. Stieglitz, an influential photographer and gallerist, had championed the European avant-garde since 1905 in his various galleries, showing the works of Henri Matisse, Constantin Brancusi, and Paul Cézanne, along with American painters, including Georgia O'Keeffe, Marsden Hartley, Arthur Dove, and John Marin. Stieglitz was the first gallerist in New York to show African art as fine art. The artists represented in his galleries were engaged in developing abstract pictorial languages rather than in conveying stories, and Knight was drawn to much of the work there: "We went to An American Place all the time . . . the work shown there was the basis of American art. . . . I admired O'Keeffe, though her work was cold. I loved Dove; he was my favorite artist there."

Dove and O'Keeffe both painted from natural forms, extrapolating from basic shapes and freely interpreting the character of their subjects. Dove in particular pursued the idea of equivalence in his work; he attempted to create images that would conjure the same feeling in the viewer as the original landscape or natural feature had for him. O'Keeffe's paintings enhanced the sensual aspects of their subjects and tested the limits of abstraction; her undulating lines and rich colorations re-created the world and its objects as visual and somatic sublime. O'Keeffe's paintings were dryly painted; more intellectual, they explored abstraction and the possibility of inventing entirely new—but no less compelling—forms. With his abstraction, Dove intended a more literalized, sensuous feeling for the landscape and natural objects. His works often manifested a visceral rhythm, capturing music's ability to conjure feeling. Knight was drawn to this kind of artistic interpretation: Dove's grounding in nature and his more place-bound paintings were very appealing. As her work developed, Knight became more committed to the interpretation and communication of visual delight in the world around her. It superseded the need to tell a story or to explore the larger meaning of what it meant to be a modern painter. This fundamental ambition can be seen in these early works, and it remained a significant part of her intention throughout her career.

Lawrence returned to Knight and New York in December of 1945. Early the following summer he was invited by Josef Albers to Black Mountain College in the mountains of North Carolina to teach in the summer session, held that year from July 2 to August 28. The school had been founded in 1933 as an experiment in education: a residence community dedicated to the instruction of practicing artists and the inculcation of the arts as a generative force in the lives of Americans.[15] Although the surrounding area was not liberal enough to accept mixed-race institutions, the school itself offered a freer environment. Knight remembers: "Albers got us a room when we came so we could avoid the segregation. . . . We were protected. The students and the faculty were very welcoming so we just stayed on campus."[16] Knight taught modern dance techniques on an informal basis, drawing students away from the classes taught by the painter Jean Varda.[17] Other visiting instructors that summer included the abstract painter Balcomb Green, Beaumont and Nancy Newhall (he was the Museum of Modern Art's librarian and first photography curator), and Will Burtin, the art director of *Fortune* magazine. The program included jazz concerts,

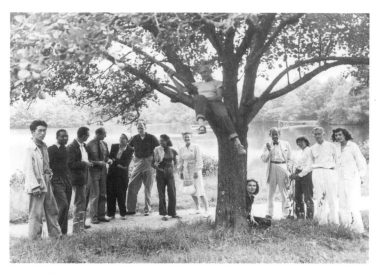

Fig. 3. Photograph by Beaumont Newhall. Summer Art Institute faculty, Black Mountain College, 1946. Left to right: Leo Amino, Jacob Lawrence, Leo Leoni, Ted Dreies, Nora Lionni, Beaumont Newhall, Gwendolyn (Knight) Lawrence, Ise Gropius, Jean Varda (in tree), Nancy Newhall, Walter Gropius, Molly Gregory, Josef Albers, Anni Albers. Copyright 2002, Beaumont Newhall, The Estate of Beaumont and Nancy Newhall. Courtesy of Scheinbaum and Russek, Ltd., Santa Fe, NM, and North Carolina State Archives, Black Mountain College Papers.

films, and an all-school extravaganza built around the theme of Greek mythology, for which Varda constructed a Trojan horse and Knight wore a costume she made from the draperies in their room.

The heady mix of intelligent, opinionated faculty and the hothouse environment of a small campus contributed to an intense summer of learning and interacting. Lawrence acknowledged that Albers not only influenced his views on abstraction but also convinced him to develop a philosophy about his work. Knight didn't formally study, yet she also found that she gained a great deal: "I learned a lot that I could use in my own painting. Many concepts I could use very handily. Form follows usage, that was the main thing, and thinking about space and color."[18] Albers's promotion of a strict abstraction made Knight "think more intellectually and more academically," but she stayed committed to

figurative painting: "I had already begun creating what I wanted before I arrived at the College."[19]

Upon returning to New York, Knight began to study dance with Jane Dudley and Sophie Maslow, who had formed The New Dance Group. The two dancers, who were members of Martha Graham's company from 1937 to 1944, had established an influential school of modern dance in 1938. They taught Graham's principles, which included not only the rigorous consciousness of muscles and their positioning, but also the notion of movement as originating in the unconscious.[20] They were especially interested in working with non-dancer audiences, so they performed in all kinds of venues, including union halls. Their dance technique was expressionistic, and in this period they often set their pieces to indigenous American music, from Leadbelly's harmonica to Miles Davis's improvisational jazz. Their own choreography, like Graham's, encouraged interpretation of narrative and incorporated improvisatory movement. Knight remembers her study there with enthusiasm, enjoying both the movement and the idea of creating symbolic content. It seems very likely that her artistic ideas about emotionality and art as a means of humane connection to the world were reinforced there. She also gained some understanding of the process of her painting as movement, and the relationship between dance and design: "There is a physicality . . . the way you move on paper has something to do with what comes from it."[21]

In October 1949, Lawrence was admitted to Hillside Hospital. He was suffering from depression, and he would remain in the hospital for eight months. This was a difficult time for many artists. A number of strong support systems had completely disappeared: the artist cooperative networks collapsed after the war, and very few gallerists (among them Marian Willard, Samuel Kootz, and Edith Halpert) offered opportunities to African Americans. This era and generation also lacked a strong spokesperson; there was no one like Alain Locke, who had earlier so eloquently outlined the possibilities of art for the African American community. The writer Amiri

Baraka recalled later that many artists and writers disappeared, giving up their professional careers or relocating outside the United States, or becoming what Ralph Ellison would call later the "invisible men."

The gallerist who showed Lawrence's work, Edith Halpert, found Knight a day job at Condé Nast in 1950.[22] Knight worked first as an assistant in the archives of the publisher, and then as assistant to the art director of *Glamour* magazine until the early 1960s. Although Lawrence resumed teaching, his positions were always temporary. Knight's employment would provide a stable income for a decade. In 1957 they moved into racially integrated, middle-income housing in Brooklyn, where Lawrence used the second bedroom as his studio, and Knight, when she wanted to, would set up in the living room. Working would leave Knight little time to paint. Instead, she continued to dance for artistic release, and, as a consequence, virtually no paintings remain from this period of her life.

At this time, the couple's financial circumstances were not predictably secure, and the trend toward abstraction had left the market for figurative work very dry. There had been an important shift in art over the course of the 1940s. After World War II, more and more artists explored their own ideas and feelings; fewer felt obligated to express political positions. Art in service to social issues became a thing of the past for most artists. Instead, painting became very personalized, and many artists left any kind of narrative behind for improvisational movement in which the unconscious motivated the mark-making process. Harold Rosenberg coined the term "action painting" for this work, to express a new conceptualization of painting as evidenced by the works of Jackson Pollock, Willem de Kooning, and others. During this time, Knight's style did not change. Although Lawrence continued to be, fundamentally, a figurative painter, his works became far more abstract, and he was very much antagonized by the new climate. Knight persisted in connecting with her subjects and continued to treat the process of painting as an exploration of their form and their significance. The expressive

possibilities of her subjects continued to be key in her work, and she balanced her interpretations between representation and a lyrical expressionism. She was always thinking about painting, and about art. She painted directly; there were no preliminary sketches. In fact, she treated sketches as finished works, as if to demonstrate that simple but thoughtful intervention could transform something that captivated the eye into a lasting image.

Knight developed her improvisation by doing portraits using live sitters. These paintings are character studies, and Knight focused attention on a new kind of brushwork, articulated and visible, and different from her earlier compositions built from flat shapes. There is atmosphere and light in these loosely, apparently quickly painted pictures, such as *The Actor* (page 54), an oil painting from the early 1960s. Different areas of colored paint build the shape of the head, delineate cheekbone, and describe hair. Blue is set against orange, red against green, in Knight's characteristic use of color, but the paint is handled much more freely than in her earlier works. Fields of color are modulated, conveying the sense of light flickering on a surface and strengthening the feeling of observed immediacy. The figure is portrayed with little environment; the lack of milieu suggests the isolation of contemplation, a pose of reverie. There is no personal judgment in her portrayal; Knight's painting conveys instead a strong sense of her visual experience. It provides a sharp contrast to her earlier painting of an actor, *Mask:* while each painting presents something of an archetype, the earlier image presents a literal mask, an imagined, graphic reduction, while *The Actor* presents a momentary observation of a person in the midst of deep thought.

Another painting done around the same time, *The Redhead* (page 54), demonstrates this development of Knight's observation and improvised brushwork. The porcelain coloration of the woman's face and the ethereal cloud of light auburn hair are well observed and gracefully translated. *Dorothy* (page 53), painted in 1963, shows a further evolution. The woman's face,

shirt, and hair are painted in large, broken, and dry strokes that are echoed in the space around her head, creating a luminous image. As before, Knight's strong sense of color is key: she draws a blue from the head scarf and uses a variation of it to indicate the features of the face, creating another means of lighting the sitter as if from within. In these portraits, there is little psychology: instead, Knight pursues and enhances visual characteristics to define the sitters. She painted from life, but almost all of her sitters are identified by a characteristic rather than by a name. This continued her practice of using generic titles, as opposed to naming the actual places and people she painted. It reiterated Knight's distance and animated the subjects' function as archetypes. During the 1960s Knight made a series of portraits from life that continued to maintain this kind of distance via their titles; often she would title a work by naming a color, such as *Yellow Jacket* (page 58), *Portrait, Red Dress* (page 59), and *Lady in an Orange Dress* (page 57). These portraits also display a detachment on the part of the sitters: they look down or away from the artist. The brushwork in each is lively; the colors are intense, usually complementary. They are sensitive observations and show Knight's love of and use of color. Her characteristic color play is set up in the resonance of odd shades of complementary colors, such as greens tinged with yellow, and reds cooled to pink or darkened to near purple. In this way she was able to incorporate their subtle visual vibration and create an almost physical sensation. Sometimes this physicality imitated the play of light on skin; at other times she used it to create a barely discernible uneasiness, almost an irrationality.[23]

Some of this new involvement with paint may have been influenced by study with Anthony Toney at The New School for Social Research. Knight took classes with him off and on from 1960 until 1966. "He was a good teacher; he knew how to create the basics: color, space, every visual need." He also imparted a sense of the larger philosophical questions surrounding art and artmaking. Another key factor was the simple availability of models in his classes; Knight could paint from live sitters with a regularity she had not enjoyed until this time. Toney's own figurative paintings were an eccentric combination of realism and graphic compositions. His imagery was largely symbolic and his content tended toward the political, but in his classes Toney encouraged his students to work to discover their own aesthetic path. Knight was comfortable in this setting, and she made friends with a number of students from these classes. They would visit museums together and talk about art. The period seems to have been a very rich one for Knight, despite increasing civil unrest in the city around her and across the country.

The late 1950s and 1960s were a tumultuous time for the United States as the country divided rancorously over civil rights and the Vietnam War. Much dissent was played out in public, in political debate, demonstrations, and riots. The assassinations of President John F. Kennedy and the Reverend Martin Luther King Jr. shocked the world. In the African American community, the lack of progress in achieving equal rights and integration led to a rekindling of Black Nationalism. In this atmosphere, Lawrence and Knight decided to go to Africa to view its cultures first hand and to make their work in a different environment.[24] They obtained assistance from the American Society of African Culture, and in 1964 they traveled to Lagos, Nigeria. The country had just obtained its independence from Great Britain, and Lawrence and Knight spent eight months there, the first half of their time in Lagos, then in Ibadan, where they secured an apartment in which they both could work. Knight invited people to pose for her, and she also painted from memory the scenes that had stimulated her when she and Lawrence went out to walk or to go to the market.

Without trying to be too selective, Knight looked at all types of culture and production, from African art and artifacts, such as masks, to daily life, its directness in sharp contrast to the complex of American consumerism. Everything was inspirational. She returned to the compositional device of broad fields of interlocking color and drew elongated and distorted

figures. In *Mask I* (page 53), 1964, the body is almost nonexistent while the mask takes on real power, both in terms of scale and the intensity of its color. The eyes and tongue are boldly pigmented and graphically segmented; the profile with its gaping jaw is aggressive and threatening. Another painting from that year, *Mother and Child* (page 52), is painted in the same way, with expressionist distortions of forms and bright colors that describe figures and objects but also often act independently of description. The handling of paint is somewhat more complex than in the earlier work; the palette recalls Knight's earlier secondary-color combinations, but there is an immediacy of application and a new incorporation of brushstroke and drips. The device of interlocking shapes is also recalled from earlier work, and this dominant graphic quality removes the image from reality, marking it as symbolic, archetypal invention.

Knight and Lawrence came home from Africa very early in 1965; in a kind of culture shock they resumed their New York lives. Lawrence took a job at Brandeis University and they lived in Boston for a year, moving back to New York in January 1966 to live near Columbia University. Knight enrolled for further study with Anthony Toney at The New School. She and Lawrence shared a studio on 125th Street. She painted mostly portraits again, with a deliberate consciousness of paint and picture plane that rendered her paintings more abstract, their compositions formulated by brushwork rather than structured by shapes. An example from this period is *Stephen* (page 56), a portrait rendered almost completely by broad brushstrokes in vivid color. Stephen's clothes are brightly colored, thin stripes of paint, while his face is indicated with wider marks of purple, yellow, green, and red. His hair is a thick mass of short black strokes. The background does not recede but is an emphatic field of strong diagonal lines of color. It creates the effect of merging with Stephen's form and focusing attention on the paint rather than on describing his features, perhaps as a means of conveying his personality. Knight added to this effect by leaving some of the ground unpainted and exposed.

Knight showed her paintings increasingly in exhibitions in the late 1960s. Her work was included in "Portrayal of the Negroes in American Painting" at the Forum Gallery in New York in 1967, along with works by Hughie Lee-Smith, Raymond Saunders, Ernest Crichlow, and Lawrence. In fact, African American art began to be a focus of exhibitions at the end of the 1960s, in response to pressures brought to bear by the Civil Rights movement, but not always to salutary effect. The huge exhibition "Harlem on My Mind" was shown at The Metropolitan Museum of Art in New York in 1969; in response to its depiction of the Harlem community (it was an exhibition of photographs of African American life rather than a gathering of works by different artists), the African American community demonstrated, and a number of artists, led by Benny Andrews, Henri Ghent, and John Sadler, formed the Black Emergency Cultural Coalition, which lasted from 1969 to 1971. The exhibition was hugely disruptive to the African American community, creating a severe rift between those who felt that the attention, however late, was good, and those who felt that their community was grossly misrepresented. Lawrence, who had sat on a public presentation panel at the Met the year before, felt frustrated by the persistent need to differentiate "black art" from other art, and was also increasingly challenged by his students at Pratt Institute.[25] Knight stayed away from the debates and from making any public comment.

Knight and Lawrence maintained a balance between the rigors of New York's political debates and their own private experimentations by accepting invitations for Lawrence to teach temporarily in schools around the country. From 1968 until 1972, each summer they would go to Maine to work and study at Skowhegan School of Painting and Sculpture. In 1969 Lawrence was a visiting professor at California State University at Hayward, and they lived in Berkeley for the academic year. Knight always accompanied him on these sojourns, and she painted whenever she could, although the logistics of their temporary situations often made this difficult. The temporary

nature of these residencies did not support the discipline of setting up and isolating herself to paint, and more often the time would be spent investigating the new place and in the company of new colleagues. In Berkeley, Knight happily attended life drawing classes, making finished charcoal sketches from posed models.

In 1970 Lawrence was invited to teach the spring quarter at the University of Washington in Seattle. He returned to New York, but the university followed him with an offer to return to teach full time, as a full professor with all the benefits of employment—something that Lawrence had never had. Although he also had other offers to teach full time, he accepted the university position, and he and Knight moved to Seattle in 1971. They continued to travel, usually at the invitation of an institution or in conjunction with an exhibition of Lawrence's art. They took a trip to Europe almost right away, visiting Paris, London, and Munich, where the 1972 Olympics were held, for which Lawrence had designed a poster. Lawrence had been successful for a long while in terms of public awareness of his art, but the move to Seattle would mark the first time they could relax into the security of a known future, and it would provide a basis for Knight to pursue her painting without the weight of financial worry.

Knight continued to paint, retaining her interest in portraiture and the figure. She had her own studio, first a room next to the garage of the house they rented, and later a studio in an apartment close by. The ferocious debates of New York were left behind, as was the intellectualizing about art and its production. The Seattle community was a much gentler place; artistic differences were less stridently expressed and less divisive. Francine Seders invited Knight to join her gallery, where she featured her in regular solo exhibitions and included her work in group shows. Knight also showed her work in various group exhibitions, including the annual Urban League shows from 1974 to 1984. The exhibitions afforded her opportunities to paint, creating a different kind of impetus, and her art evolved slowly. She opened up to new ways of working, choosing

different media. She made a number of drawings of musicians and dancers performing, quick sketches without careful composition, but full of gesture and the immediacy of music. She drew from life but also used others' pictures for inspiration, including a book of Barbara Morgan's boldly composed photographs of Martha Graham and other dancers in the midst of their signature movements.[26] She also looked differently at ordinary things in her immediate surroundings and explored the role of imagination, not simply in interpretation, but as a means of generating a completely new type of picture. Experimenting with traditional subjects, such as posed figures and still lifes, Knight tried to imagine them anew. In *Flower* (fig. 4), an oil painting from 1981, she pictured the interior of a flower, using very softened versions of her characteristic color combinations.

A quick reading of this image might reference similar works by Georgia O'Keeffe, but the differences between her flower imagery and this painting by Knight are telling. O'Keeffe's

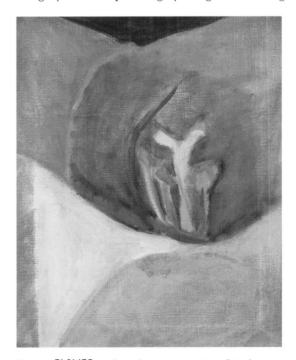

Fig. 4. **FLOWER**, 1981, oil on canvas, 20 × 18 inches

deep colorations and furrowed lines sexualize her flowers, while Knight's soft colors and broad shapes redefine the flower as a landscape. Her painting portrays the possibilities of the imagination at play in the visible world; it is much less specific and polemically conceptual than the paintings of O'Keeffe. In this broad exploration, Knight began to develop figures from composite memories, rather than from life. Her figurative paintings from the mid-1980s are very similar to her earlier, archetypal portraits, but with this important development in terms of the generation of their ideas. Knight defined this way of working as "female" painting and juxtaposed it with the "feminist" work of O'Keeffe:

> I think that feminist painting has something to do with the intellectual, with philosophy; you're putting into visual language what you should have and what's happened to you—it's more protest. . . . A female painting has something to do with the psyche. I think it has something to do with what's happening inside of you, your psyche and being a woman. . . ."[27]

Although a later, retrospective remark, this statement demonstrates Knight's opportunity to reflect on her work and its motivations. Her paintings during the 1970s and 1980s continued her earlier methods, but now she considered them to be meaningful beyond the recognition of personality or the reading of an obvious symbol. She had more time to contemplate her choice of certain subjects; she turned from the world outside to her own thinking and began to generate ideas and invent images, sometimes selecting and refining iconic subjects she had worked with before. In the late 1980s she created a small series of figurative works that had religious overtones, using jewel colors and somewhat geometrized forms to compose the images. Two of these date from 1987: in *Robes* (page 67), a black woman and a white woman meet; while a related image, *The Garden* (page 68), 1989, portrays Eve from behind—with the apple prominently displayed in her hand, she appears to turn away from the viewer and toward something unseen. Each of

the three compositions is very simple, presented in shallow space, with the colors rather evenly applied and the details suppressed. Each focuses on human possibility and pictures a moment just before a decisive event takes place. The weight of important decision is very present, and the sense of narrative very strong. This is a rare episode in Knight's body of work, although it contains some of her characteristic elements.

Knight's artistic reputation developed quickly during these years. In 1988 she was given a one-person exhibition at the Virginia Lacy Jones Gallery at Atlanta University. Her works were requested for book covers, and she was honored several times with awards.[28] She began to work more experimentally with media in combination, such as chalk over gouache or oil. The gestural lines of chalk have the effect of enlivening the forms underneath; this can be seen in an untitled painting of a seated woman as well as in one of a series of mask paintings, *Mask III,* from 1988. The technique is also used, perhaps most effectively, in *The White Dress,* from 1989 (page 69), in which the chalk lines draw and redraw the face of the woman. The woman's silhouette is conveyed very simply by the outline of the white shape that is the dress: she is pregnant and holds a round object (perhaps a fruit) in her outstretched hand. The general shape of her head and hair are given in gray and black forms, with quickly sketched black lines indicating two faces, one in profile and one possibly turning toward the viewer. It is an economical and compelling image, and one that Knight later chose to reinterpret in a graphic medium (see page 8).

Portraiture remained a constant in Knight's oeuvre. A rare self-portrait from 1991 (page 20) is less brushed and more constructed than the portraits made in the 1960s. Larger, flatter areas of color compose the face. It, too, is set in a shallow, brightly colored space, but it effects a different and direct engagement of the viewer, with eyes that look unswervingly out of the canvas. Knight shows herself not as a contemplative or passive subject, but as a subject in charge of her circumstances. Knight enjoyed working with live models, and her attention to

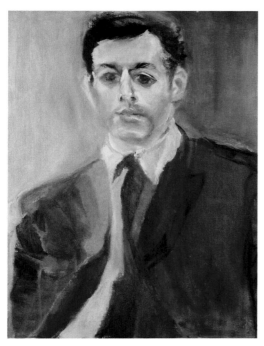

Fig. 5. **PORTRAIT OF A MAN IN A TIE**, 1960s,
oil on canvas, dimensions unknown

the animation of faces in the changing conditions of daylight attests to her pleasure in this kind of imagemaking.

Knight's work in the 1990s utilized two distinctly different ways of generating imagery, both involving printmaking. She was invited to create a lithographic print for the Brandywine Museum in 1992. She developed a new image with the familiar theme of mother and child for this commission, which required learning about the technique so that she could effectively design an image to be printed. The resulting lithograph, *Lullaby* (page 71), is composed of interlocking colors. Except for the strong outline, a new feature that may have evolved during her use of a lithographic crayon, it resembles a number of Knight's earlier works. The figures are defined by simple, blocky forms, and their reduced description is countered by the expressive manipulation of relative scale. For example, while the mother's head is somewhat small for her long body, the hands are large. In her first lithographic

endeavor, Knight understood the character of the medium very well, even overlapping transparent pigments to create new colors and impart a sense of depth.

Knight next tried serigraphy, or silkscreen. She chose to reproduce a small painting from 1991 titled *Pleas and Thank Yous* (page 70), a graphic image of a single figure which featured a brilliant red. She worked with printer Lou Stovall in Washington, D.C., and together they developed the translation long distance by sending the images back and forth.[29] Stovall would interpret her desires, and Knight would then review the proof, write her thoughts on it, and send it back. Finally, the image was finished (somewhat fittingly titled *Diva* [page 6], as it was larger, at more than double the original size, and more powerful). The process was difficult for Knight, who valued spontaneity in her process. She preferred being able to take advantage of what was happening immediately before her on the canvas without having to rationalize and verbalize in the midst of imagemaking. Still, the serigraph is remarkably truthful to the original painting, and its accomplishment may owe much to the fact that it was an interpretation of an existing work rather than an attempt to create a wholly new image.

The success of her serigraphic print prompted another project in 1994; this time Knight chose another existing image, *The White Dress*. It was also an image composed of large graphic shapes, suiting the silkscreen process, which is essentially a stencil producing defined lines and unmodulated color. As Knight noted, the silkscreen process radically alters the painted image, remaking it to become "stable and deliberate."[30] Knight and Stovall had to reinterpret the subtleties of drawn lines and scumbled color, a difficult challenge, but again the final print was judged a success (page 8). In 2001, the pair undertook another reinterpretation. This time the image, although similarly graphic, was a very early work, the painting of a tropical flower made in New Orleans in 1941 (frontispiece). The silkscreen, because of the simplification required, actually improves the legibility of the original. The small figure behind the plant is much more visible in the print

than in the painting, and the line of her dress has been redrawn to better relate to the shape of the fruit.

In 1994 Knight made a breakthrough in her printmaking and dramatically changed her way of working. Encouraged by Elizabeth Sandvig, an artist and a friend, she began making monoprints in Sandvig's studio, using her printing press. Knight's affinity for improvisation and lyrical movement found its métier: the monoprint's simplicity and ease of process allowed her to draw her images quickly and take advantage of chance. Knight experimented with different ways to move the ink around the glass plate, drawing lines as well as massing shapes. She chose subjects first from her immediate surroundings, including Sandvig's cat, then, as she grew more proficient, from her imagination and memory. "It's a freeing type of print. It's the accidental. . . . It's quick, I like that. . . . You can do something you might be afraid to do in your painting."[31]

The necessary rapidity of the monoprint process may have been the impetus, in part, for Knight's brief consideration of abstraction. Several prints made in 1994 do not depict a recognizable subject. Biomorphic in its sensibility, *Meditation* (page 74) is a graceful set of curves in which a round form is embedded. It could be an eye, or a rock in a streambed, or an oyster with its pearl sitting in a soft, almost fleshy pillow, but it is, in fact, a figure in a yoga pose. Knight drew the image in blue and black on a ground of soft green that she blotted to give texture. Much of the paper is left bare, and the image flips back and forth between a soft kind of realism and complete abstraction. One of a series, *MoonWalk II* (page 75), is also drawn and is similarly biomorphic. For this print, Knight laid down a black ground and, with a stylus, cut her image into the ink. These figures are, again, vaguely representational but remain ambiguous. The lines look continuous, as if Knight drew them without picking up the point of her stylus. This brief series of images provides a strong sense of Knight's preference for lyricism and movement in her imagery; while not directly allusive to dance, the gesture in both these works dominates, recalling the rhythmical, linear tendencies of her works of the 1940s.

Knight made some complicated works in monoprints, but most of them are very simple and figurative, usually incorporating some kind of silhouette. Most retain a sense of the process of their drawing, in their multiple, energetic lines or clean edges that curve gracefully in shorthand description. She created a number of images of horses in the late 1990s, expressing the animals' grace and muscularity (pages 76–79). Although horses were not her favorite subject (she recalls being frightened of their strength and angered by what she saw as their exploitation as carriage horses in Central Park), she nonetheless was engaged by the idea of their "enormous, powerful, beautiful" movement. The equine images are completely imagined, drawn from memory. They are emblematic and essentialist, a fitting project for an artist whose fascination with the figurative and vitalist outlook remained an artistic constant throughout her career.

For more than sixty years, Knight has carried forward the careful observation of intimate detail and the lyrical manipulation of line and color. She strives to capture essential humanities with both, acknowledging the small moments, seen and felt, that contribute to memory. In this way her work relates most easily to the generation of artists who went before her. Knight deliberately looked outside of her own milieu, where she was surrounded by artists who were committed to art as a significant force in society. Rather than absorb their insistence on certain narratives of historical importance, or stylistic and compositional means that challenged conventional styles, she returned to a vitalist lyricism. She turned away from African American motifs and content, incorporating instead the ordinary things of her immediate experience. Rather than connecting to history, she focused on the everyday, eschewing the heroic and the mythic for the ordinary and the tangible. Her art is a quiet argument for the personal rather than the social. She nurtured ideas that would keep her distinctly individual, deliberately removing herself from others' artistic struggles.

In addition to maintaining a reserve, her soft, expressionistic handling of paint has created another kind of distance:

for all that the work is intimate, it reveals little of the artist. The obvious design of much of her imagined works overwhelms any idiosyncrasy that might be associated with the autographic: the lyrical lines and symbolic shapes camouflage her personality. Even in her more impressionistic brushwork, she is still elusive: the quick rendering of mutable light speaks more about phenomena than point of view, about the subject rather than the author.[32] Knight's aesthetic manipulations do not interfere with the appearances of her sitters, nor do they disturb their familiarity; there is neither distracting innovation nor revelation of deep feeling. Her commitment to a personal art has been total: she has kept her opinions and herself hidden from the world and its judgments.

Knight, by her own words, is not an innovator or an artist concerned with intellectual process. She has not relied on external definitions of success or with the mastery of an other-defined program. She has avoided comparisons with other artists, including her husband, by steadfastly refusing their ambitions and painting for her own pleasure, for the connections it afforded to creative life. Her art is a vital expression of lived moments; for her—a dancer—movements, sensations, and feelings define the world and are the most important conduits of expression. Her paintings convey this sensibility: they stir complacency yet preserve a sense of connection. She repeats familiar myths, redraws familiar types, and celebrates simple, shared visions of ordinary human pleasures. Knight's art is informed by her comfort with her place in the world and by her assured confidence in her own choices.

Notes

1. Glenis Redmond, "Gwendolyn Knight: Discovering Powerful Images," *Black Mountain Dossiers,* no. 7 (2001), 11.

2. Interview with the artist, March 29, 2002. All of Knight's statements and quotes are taken from this interview, unless otherwise noted.

3. Charles H. Rowell, "An Interview with Lois Mailou Jones," *Callaloo* 12, no. 2 (1987), 357.

4. Charles H. Rowell, "Gwendolyn Knight: A Portfolio and a Conversation," *Callaloo* 13, no. 4 (1988), 695.

5. Sharon Patton, *African American Art* (Oxford and New York: Oxford University Press, 1998), 115–16.

6. Barbara Thomas, "Gwen Knight Lawrence," *Northwest Women's Caucus on the Arts* (1993), 18.

7. Melissa Riesland, "Past Lives," *Queen Anne / Magnolia News,* April 19, 1995, 11.

8. Savage was appointed the first director of Harlem Community Art Center in 1937, a position she held until 1939.

9. Savage supported the African American idea of "Negritude," a conceptualization of African culture that sought to challenge the myth of Africans as inferior to Europeans. Initially promoted in the 1930s and continuing into the 1960s, it was a reaction to colonialism and had its origins in the French Caribbean.

10. Knight, quoted in Bob Williams, "Gwendolyn Knight to Share Her Artwork in the Valley," *Black Mountain News,* May 3, 2001, 16.

11. Rowell, "A Portfolio," 689.

12. For a more detailed account of these murals and issues pertinent to artists working at that time, see Dr. Harlan Phillips, "Oral History Interview with Charles Alston, September 28, 1965," Archives of American Art, Smithsonian Institution. This interview is available on the Internet at www.artarchives.si.edu/oralhist/alston65.htm.

13. Redmond, "Powerful Images," 9.

14. Ibid., 17.

15. See Mary Emma Harris, *The Arts at Black Mountain College* (Cambridge, MA: MIT Press, 1987) for a comprehensive and detailed account of the school and the artists and students who were part of it.

16. Lea Silverman, "Portrait of an Era," *Mountain Xpress* 7, no. 57 (May 9–15, 2001), n.p.

17. Connie Bostic, "Introduction," *Black Mountain College Dossiers,* no. 7 (2001), 2.

18. Knight, quoted in Williams, "Gwendolyn Knight to Share Artwork," 16.

19. Redmond, "Powerful Images," 17.

20. See Daniel Belgrad, *The Culture of Spontaneity* (Chicago and London: University of Chicago Press, 1998), 158, on Graham's importance to the art of the period.

21. Knight, in a statement made at a panel discussion at Microsoft Corporation, March 2, 2001. This session, which included Barbara Thomas and Elizabeth Sandvig, is stored on videotape in the archives of the Microsoft Art Collection, Redmond, WA.

22. Edith Halpert was a legendary gallerist. She opened the first gallery in Greenwich Village (later moving it to 51st Street). When Stieglitz died and his gallery closed, she took on some of the artists who had shown with him. She was a strong advocate for a number of African American painters and produced one of the earliest African American art exhibitions in downtown Manhattan, "American Negro Art," in 1941.

23. In reference to Sam Gilliam's work, Keith Morrison has discussed the use of color to create certain effects, including the manipulation of the physical sensations produced by certain color combinations to "reveal aspects of spiritualness." Keith Morrison, "The Emerging Importance of Black Art in America," *New Art Examiner* 7, 9 (1980), 4.

24. Lawrence had been invited to show his *Migration* series in 1962 by the Mibari Club in Ibadan, Nigeria, and had visited at that time. He was taken with the country and thought a longer stay might stimulate him to attempt new subject matter. See Romare Bearden and Harry Henderson, *A History of African-American Artists: From 1792 to the Present* (New York: Pantheon Books, 1993), 309.

25. Bearden and Henderson, *African-American Artists,* 311.

26. Interview with the artist, May 16, 2002.

27. Rowell, "A Portfolio," 692.

28. In 1987, *Robes* was chosen for a cover of *Callaloo, A Journal of Afro-American and African Arts and Letters,* published by The Johns Hopkins University Press. In 1989, *The Ritual* was reproduced as the cover of a poetry collection, *The Eating Hill,* by Karen Mitchell, published by Eighth Mountain Press. Knight was commissioned to create a cover for Lois Prince Spratlen's *African American Registered Nurses in Seattle* (Seattle: Peanut Butter Publishing, 2001). She was honored by the Women's Caucus for Art in 1993 and received the Pioneer Award during Black History Month in Los Angeles the following year. Knight also received honorary degrees from the University of Minnesota and Seattle University in 1996.

29. Stovall had created prints with Lawrence as early as 1986, when he began translating images from Lawrence's series on Toussaint L'Ouverture into silkscreens.

30. Knight, Microsoft panel discussion, March 2, 2001.

31. Knight, quoted in Williams, "Gwendolyn Knight to Share Artwork," 16.

32. For a compelling analysis of autographic elements in the work of Lee Krasner, see Anne Middleton Wagner, *Three Artists (Three Women), Modernism and the Art of Hesse, Krasner and O'Keeffe* (Berkeley and Los Angeles: University of California Press, 1996), 154–61.

PLATES

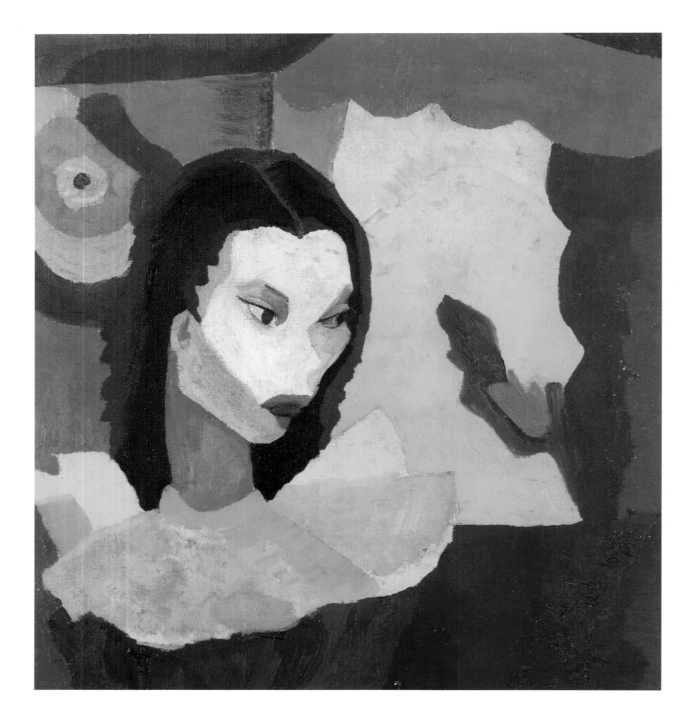

PORTRAIT OF A GIRL
1940, oil on canvas, 15 × 14 inches

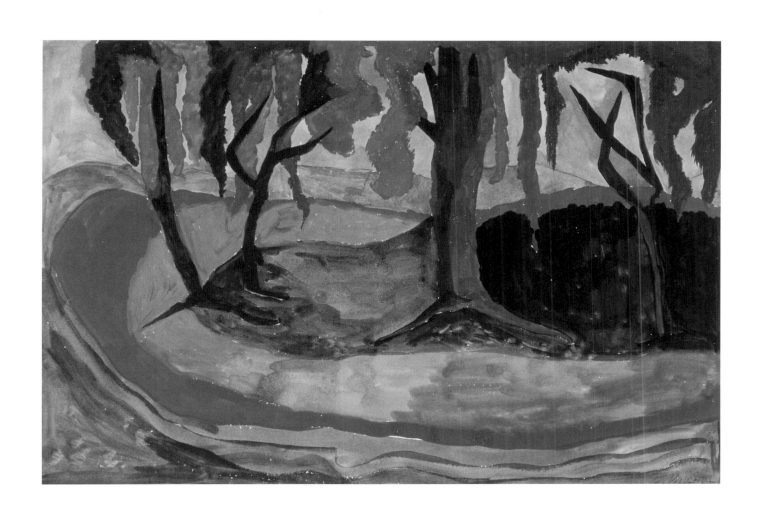

BAYOU
1941, gouache on paper, 13¼ × 20 inches

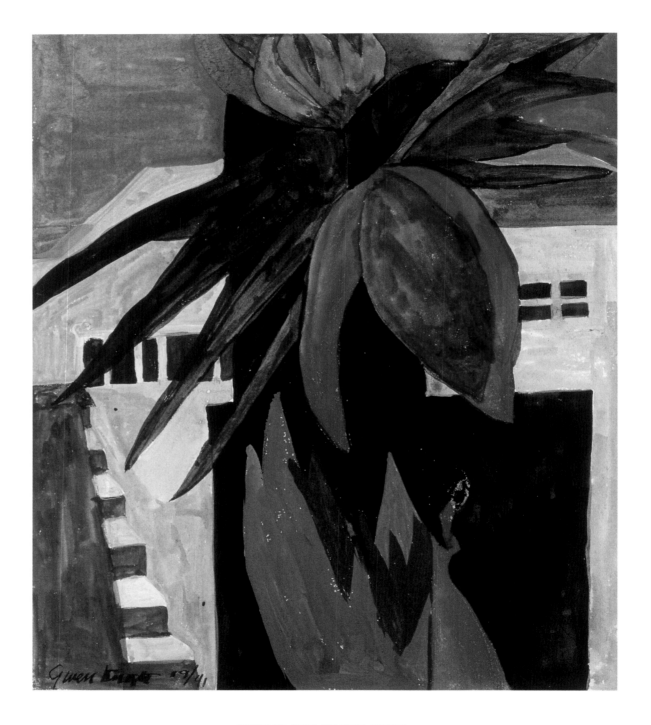

UNTITLED (NEW ORLEANS SERIES)
1941, gouache on paper, 14½ × 12¾ inches

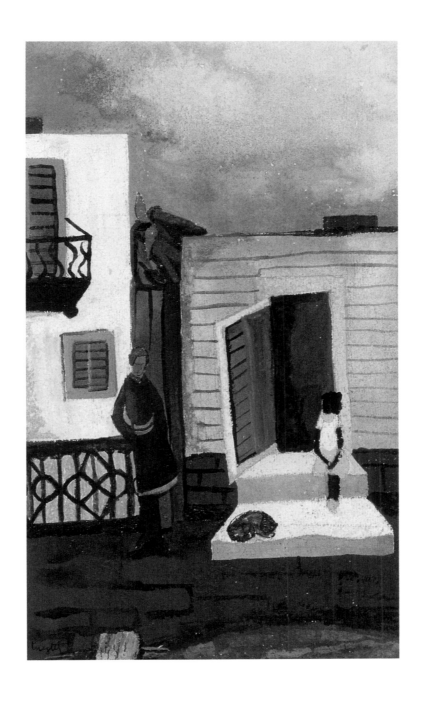

NEW ORLEANS, SCENE I (BACK PORCH)
1941, gouache on paper, 11 × 6¼ inches

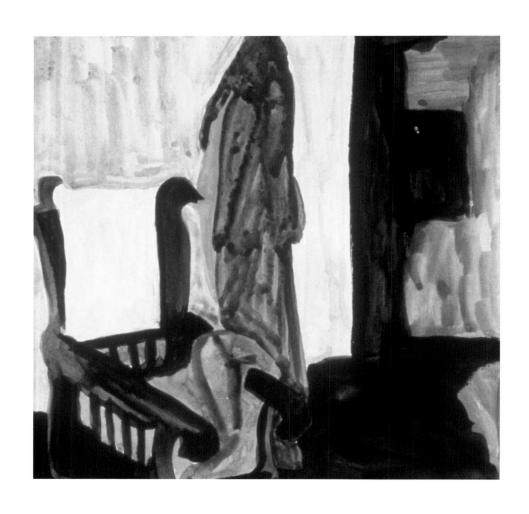

INTERIOR
1941, gouache on board, 10½ × 10¾ inches

TEA ROOM

1941, gouache on board, 10 × 11 inches

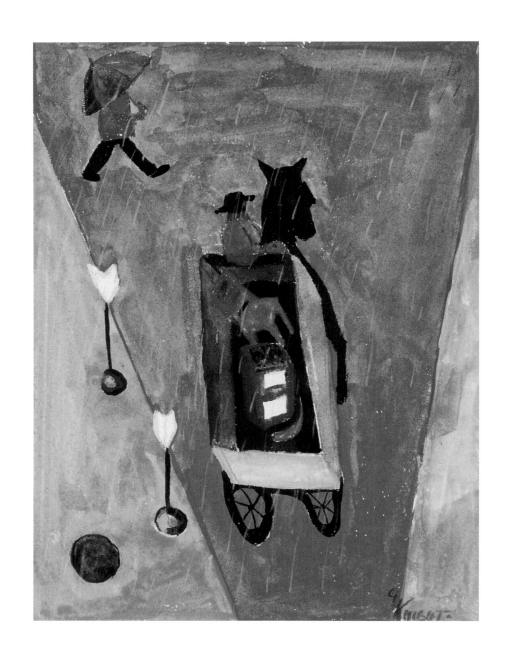

HORSE AND CART
c. 1942, gouache on paper, 8 × 6 inches

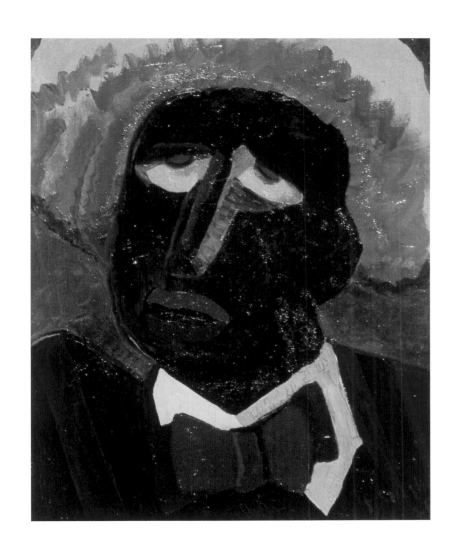

MASK

1945, oil on canvas, 15 × 12 inches

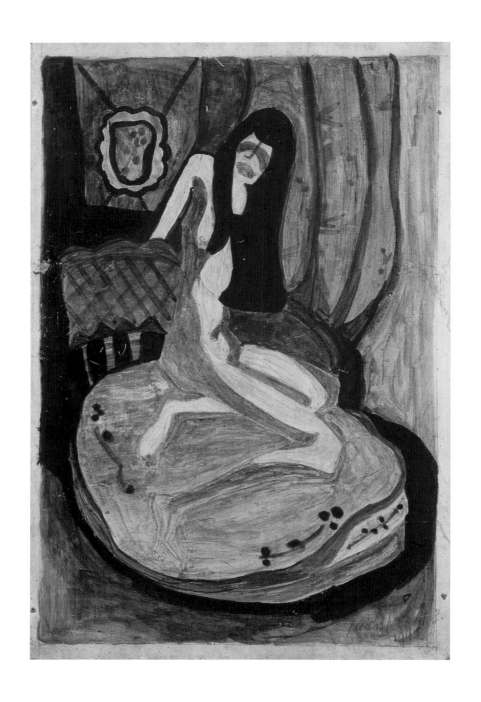

THE BOUDOIR
1945, tempera on board, 17⅞ × 12 inches

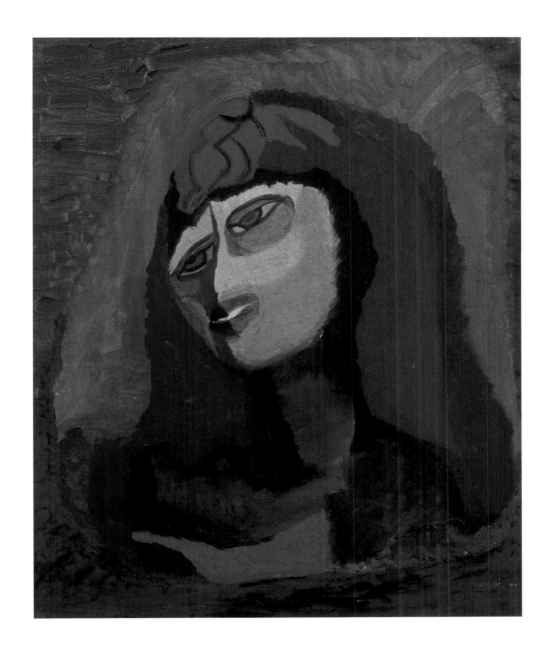

CAFÉ SINGER
1945, oil on canvas board, 23½ × 19½ inches

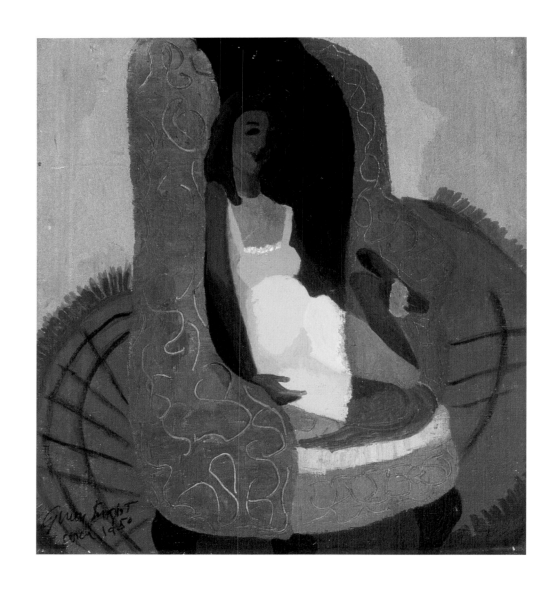

GIRL IN ARMCHAIR
1950, oil on canvas, 15 × 14 inches

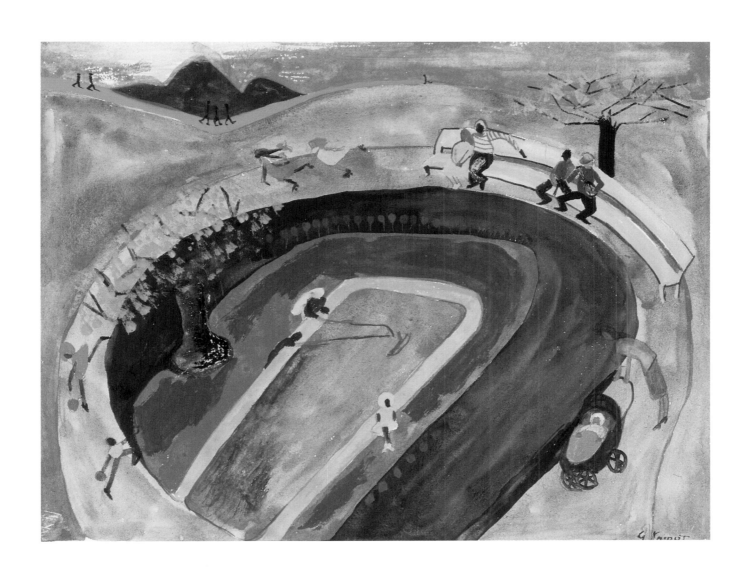

PARK
1940s, gouache, 11¾ × 14¼ inches

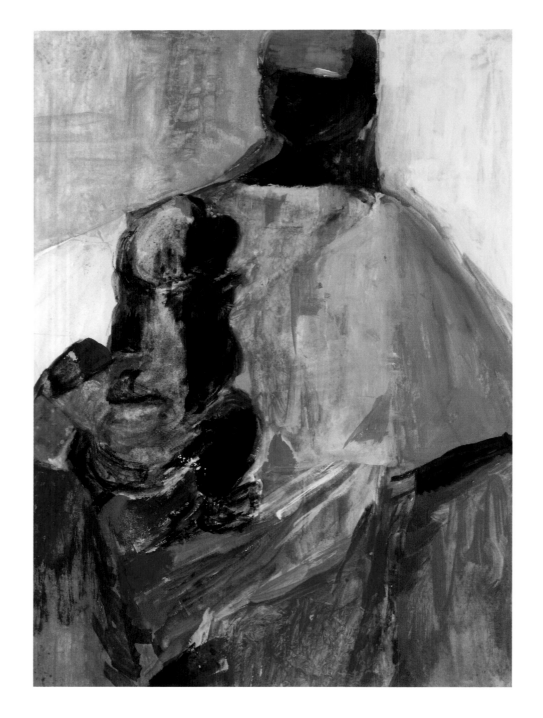

MOTHER AND CHILD
1964, gouache on paper, 14¼ × 10¼ inches

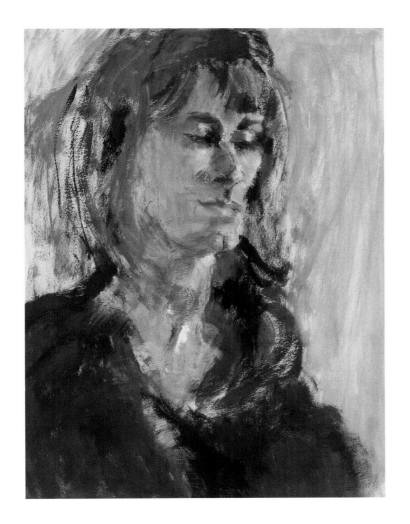

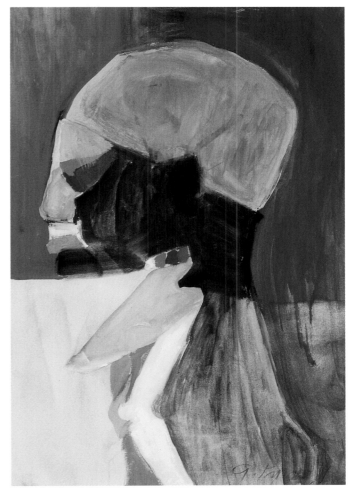

DOROTHY
1963, oil on paper, 24 × 18 inches

MASK I
1964, gouache on paper, 20 × 14 inches

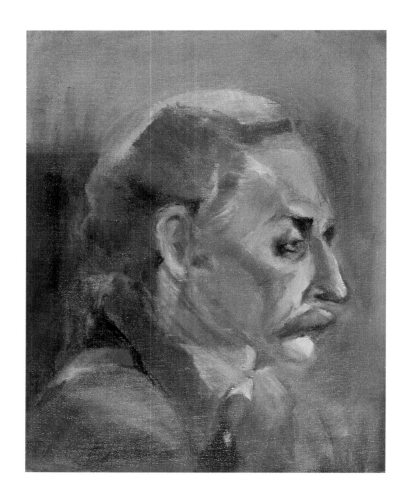

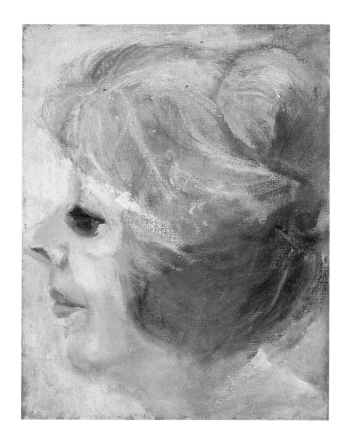

THE ACTOR
1960s, oil on canvas, 20 × 16 inches

THE REDHEAD
1960s, oil on paper, 21 × 18 inches

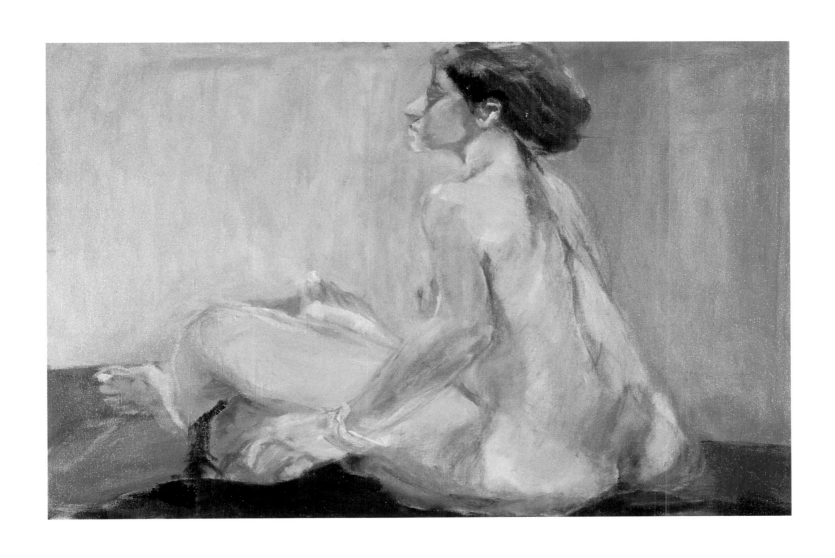

NUDE
1960s, oil on canvas, 25½ × 37½ inches

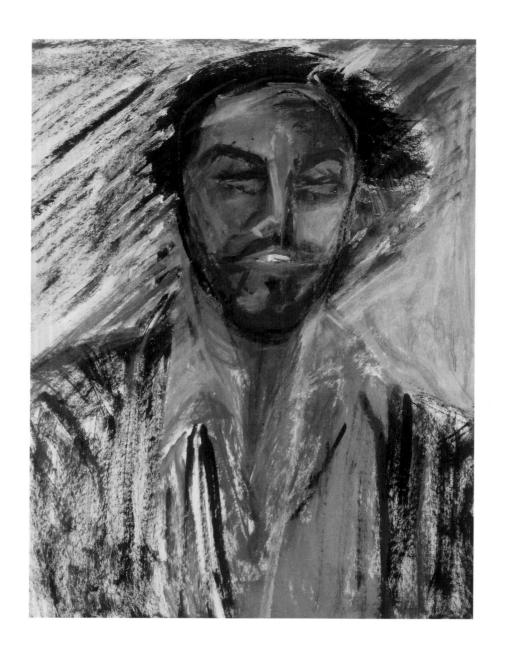

STEPHEN
1960s, oil on paper, 23 × 17 inches

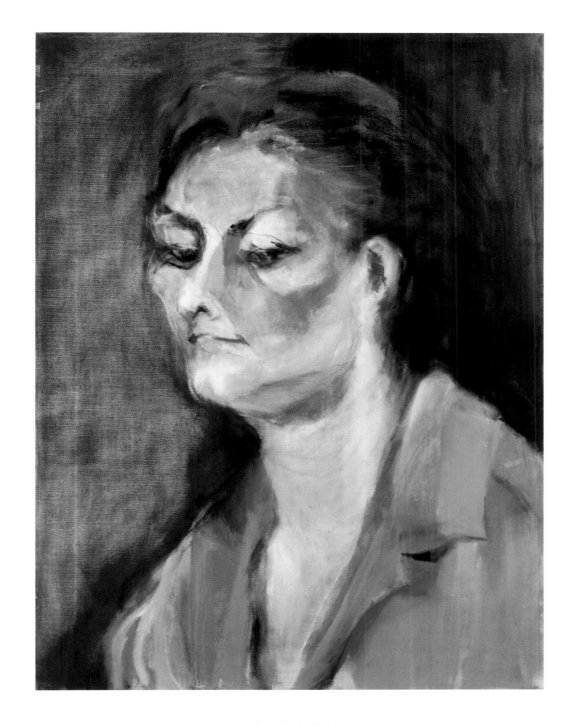

LADY IN AN ORANGE DRESS
1960s, oil on canvas, 24 × 18 inches

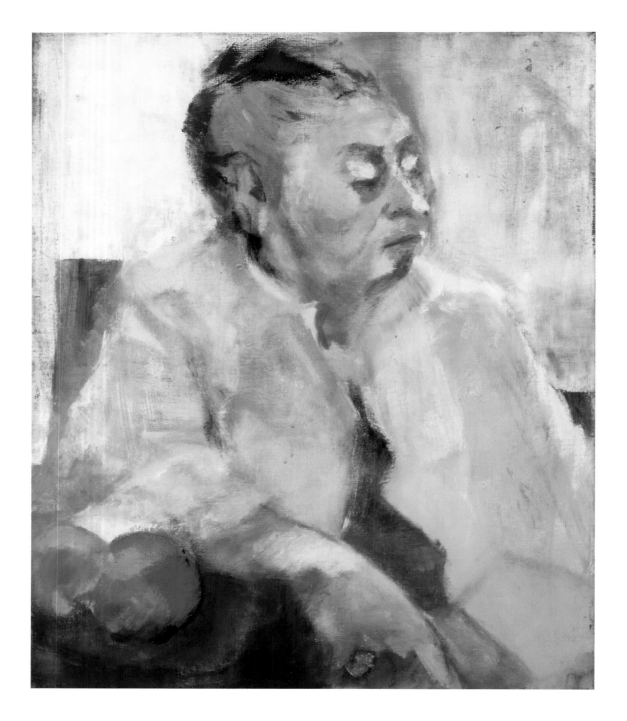

YELLOW JACKET
1960s, oil on canvas, 25½ × 21½ inches

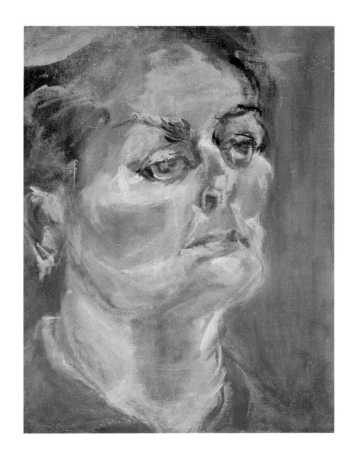

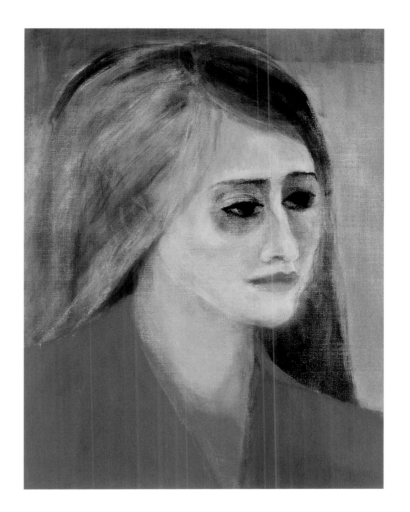

MARY
1960s, oil on canvas, 15 × 14 inches

PORTRAIT, RED DRESS
1960s, oil on canvas, 17½ × 13¼ inches

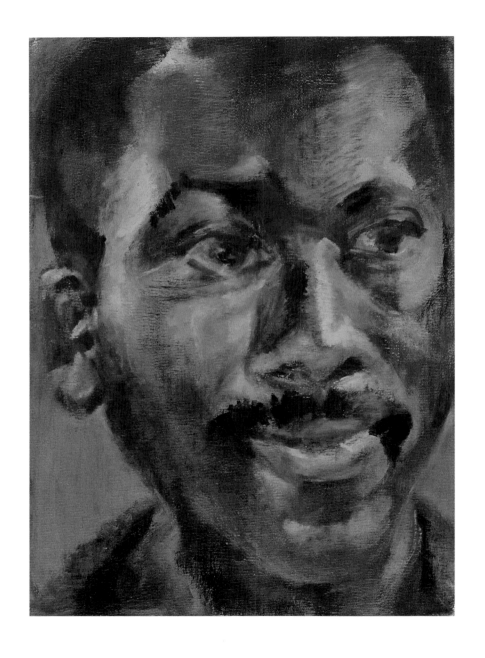

JACOB

1960s/1980s, oil on canvas, 14 × 10 inches

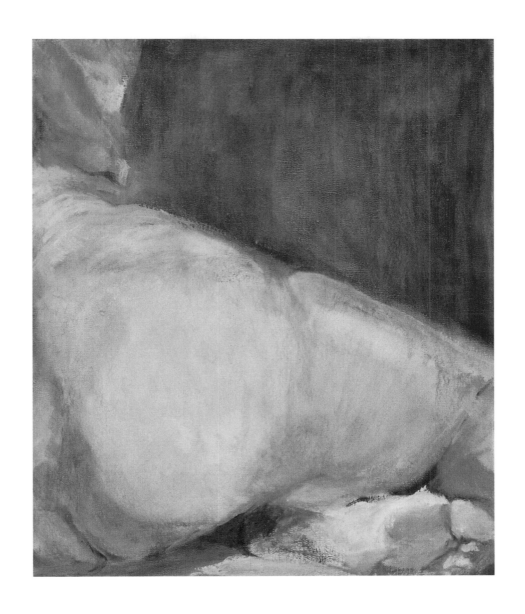

UNTITLED
1970s, oil on canvas board, 24 × 20 inches

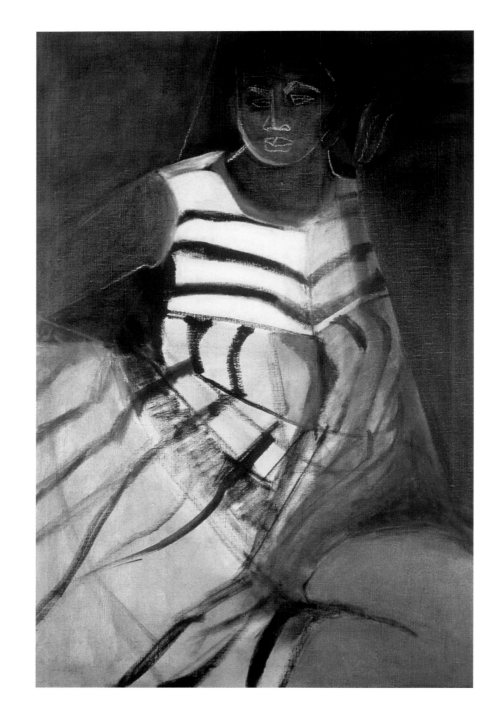

STRIPES
1970s, oil and chalk on canvas, 35 × 22½ inches

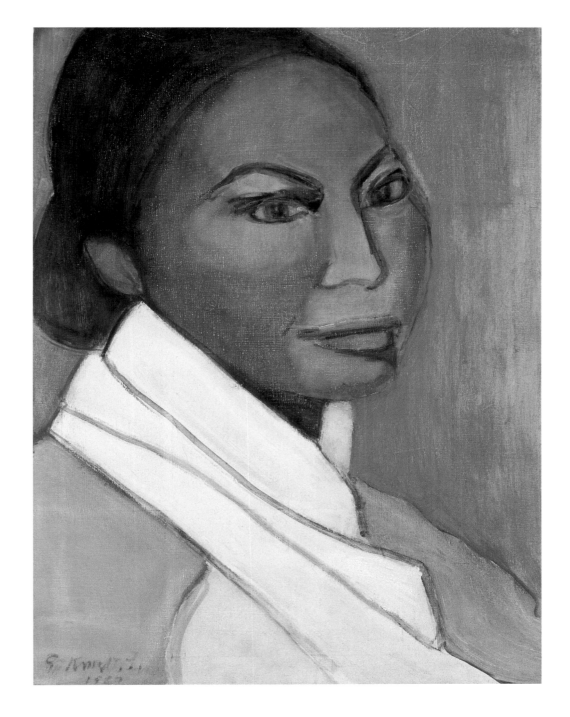

AUGUSTA SAVAGE

1984, oil on canvas, 36 × 24 inches

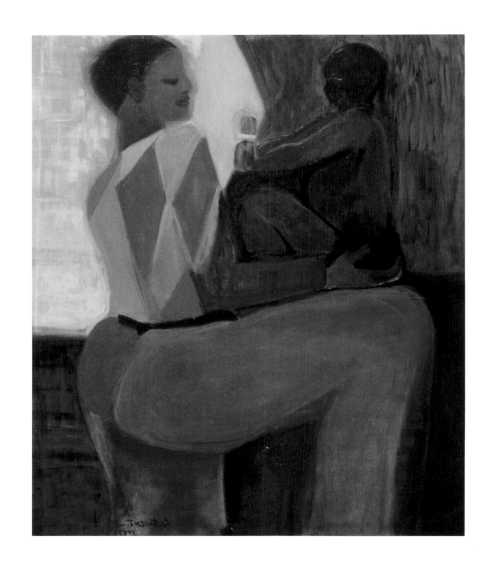

PLAYING WITH BABY
1987, oil on canvas, 48 × 40 inches

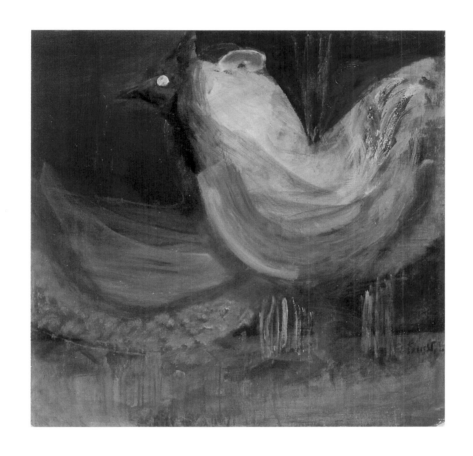

THE YARD
1987, oil on Masonite, 23 × 24 inches

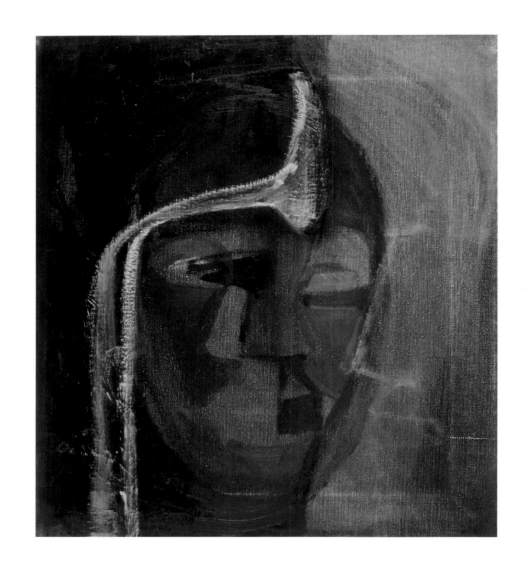

MASK IV
1988, oil on canvas, 18 × 16 inches

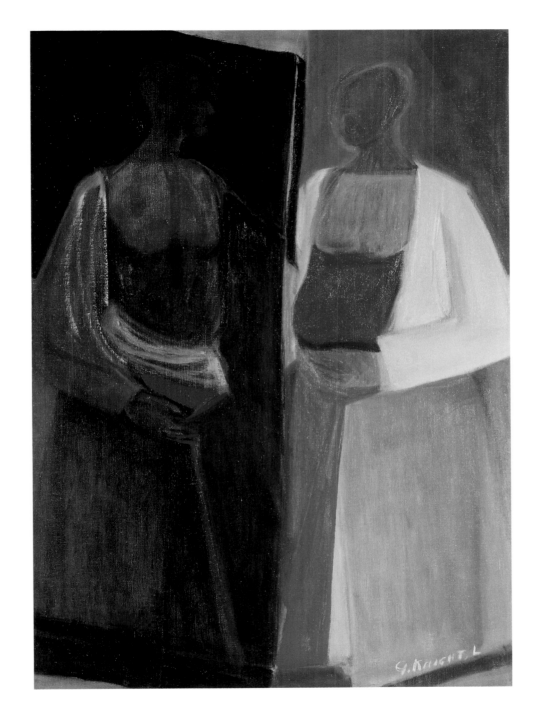

ROBES

1987, oil on canvas, 42⅛ × 30 inches

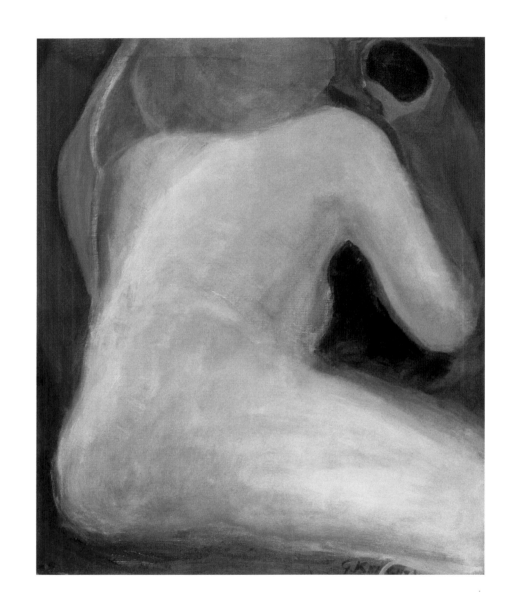

THE GARDEN
1989, oil on canvas, 32 × 26 inches

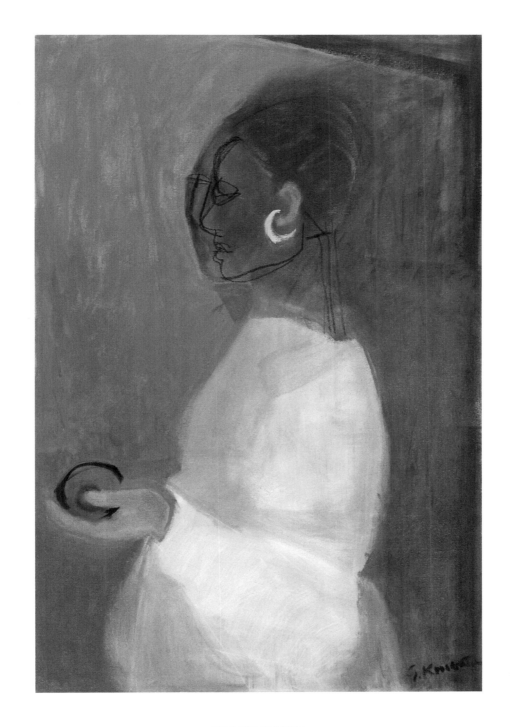

THE WHITE DRESS
1989, oil and pastel on canvas, 36 × 24 inches

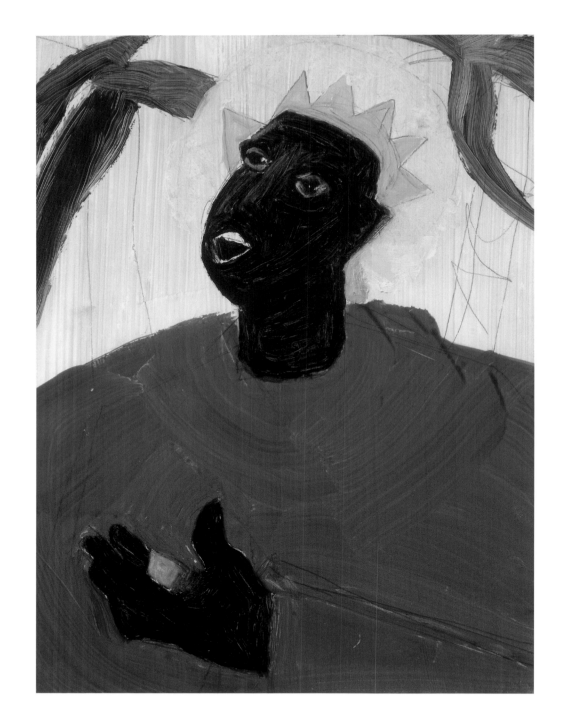

PLEAS AND THANK YOUS
1991, oil on aluminum, 11 × 8½ inches

LULLABY
1992, lithograph, 22 × 30 inches

POT OF FLOWERS
1993, mixed media on paper, 25 × 19 inches

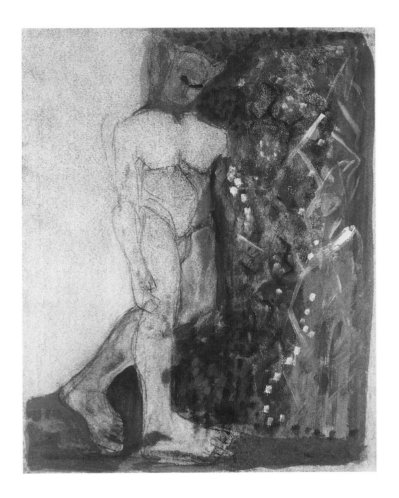

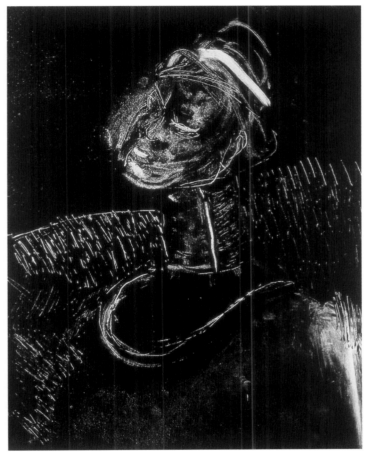

AFTERNOON OF A FAUN
1994, altered monoprint, 26 × 20 inches

AFRICAN WOMAN I
1994, monoprint, 26 × 20 inches

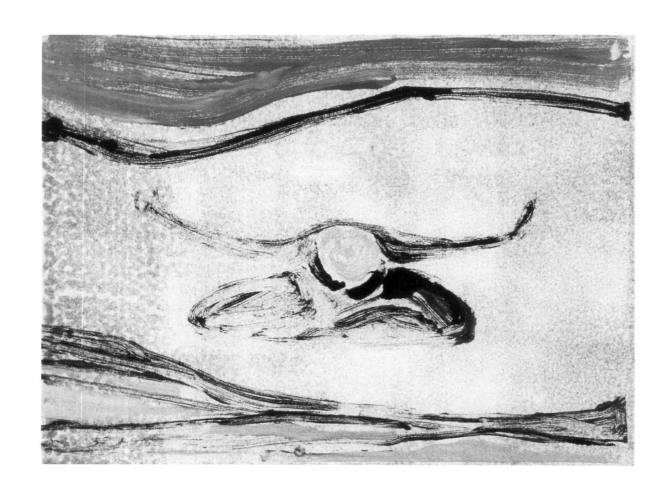

MEDITATION
1994, monoprint, 20 × 26 inches

MOON WALK II
1994, monoprint, 26 × 20 inches

HORSE VI

1997, monoprint, 19¾ × 26 inches

HORSE IV
1997, monoprint, 19¾ × 26 inches

STANDING
1999, etching, 8½ × 11½ inches (image)

78

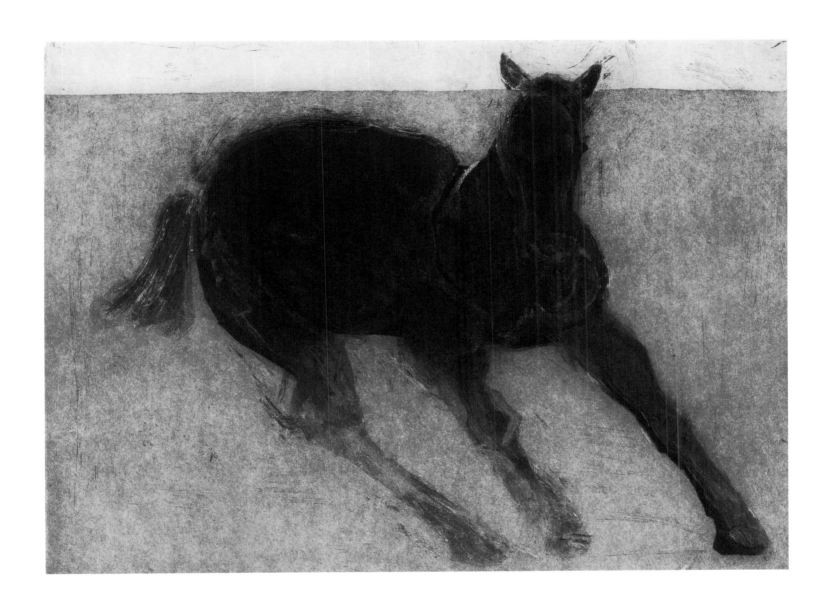

RUNNING
1999, etching, 8½ × 11½ inches (image)

THE STORIES

1999, gouache on paper, 17 × 13 inches

NEW ORLEANS
2001, serigraph, 28 × 23 inches

Exhibition Checklist

Portrait of a Girl, 1940. Oil on canvas. 15 × 14 inches. Collection of Beverly and Art Grant, Tacoma.

Bayou, 1941. Gouache on paper. 13¼ × 20 inches. Amistad Research Center, Tulane University, New Orleans.

Interior, 1941. Gouache on paper. 10½ × 10¾ inches. Collection of Safeco.

Tea Room, 1941. Gouache on paper. 10 × 11 inches. Collection of the artist; courtesy of Francine Seders Gallery, Seattle.

New Orleans, Scene I (Back Porch), 1941. Gouache on paper. 11 × 6¼ inches. Collection of Jane Ellis and Jack Litewka.

New Orleans, Scene II (Store), 1941. Gouache on paper. 9 × 6¼ inches. Collection of Jane Ellis and Jack Litewka.

Untitled (New Orleans series), 1941. Gouache on paper. 14½ × 12¾ inches. Phillips Collection, Washington, D.C.

Horse and Cart, c. 1942. Gouache on paper. 8 × 6 inches. Collection of Francine Seders, Seattle.

The Boudoir, 1945. Tempera on board. 17⅞ × 12 inches. Collection of the artist; courtesy of Francine Seders Gallery, Seattle.

Mask, 1945. Oil on canvas. 15 × 12 inches. Museum Acquisition Fund, Hampton University Art Museum, Hampton, Virginia.

Café Singer, 1945. Oil on canvas board. 23½ × 19½ inches. Collection of William and Brenda Galloway.

Park, 1940s. Gouache. 11¾ × 14¼ inches. Collection of Deborah Atkinson.

Girl in Armchair, 1950. Oil on canvas. 15 × 14 inches. Collection of Susan, Cinnamon, and Arlucius Stephens IV, Seattle.

Dorothy, 1963. Oil on paper. 24 × 18 inches. Collection of the artist; courtesy of Francine Seders Gallery, Seattle.

Mask I, 1964. Gouache on paper. 20 × 14 inches. Museum Acquisition Fund, Hampton University Art Museum, Hampton, Virginia.

Mother and Child, 1964. Gouache on paper, 14¼ × 10¼ inches. Collection of Mr. and Mrs. Lee Yates, Seattle.

The Actor, 1960s. Oil on canvas. 20 × 16 inches. Collection of Ida Cole.

The Redhead, 1960s. Oil on paper. 21 × 18 inches. Collection of the artist; courtesy of Francine Seders Gallery, Seattle.

Nude, 1960s. Oil on canvas. 24 × 36 inches. Collection of Stephanie Kowals and Andrew Dyn, Seattle.

Stephen, 1960s. Oil on paper. 23 × 17 inches. Collection of Patricia Waddy-Gayton, Seattle.

Lady in an Orange Dress, 1960s. Oil on canvas. 24 × 18 inches. Collection of the artist; courtesy of Francine Seders Gallery, Seattle.

Portrait, Red Dress, 1960s. Oil on canvas. 17½ × 13¼ inches. Collection of the artist; courtesy of Francine Seders Gallery, Seattle.

Mary, 1960s. Oil on canvas. 15 × 14 inches. Collection of Jane Ellis and Jack Litewka, Seattle.

Jacob, 1960s/1980s. Oil on canvas. 14 × 10 inches. Marshall and Helen Hatch Collection.

Yellow Jacket, 1966. Oil on canvas. 25½ × 21½ inches. Collection of Gloria and William Johnson, Columbus, Ohio.

Stripes, 1970s. Oil and chalk on canvas. 35 × 22½ inches. Collection of Linda and Jeremy Jaech, Seattle.

Figure Study No. 3, 1975. Charcoal on paper. 23⅝ × 18 inches. Museum of Modern Art, New York. Gift of Alice C. Simkins.

Figure Study No. 6, 1975. Charcoal on paper. 25 × 19 inches. Collection of the artist; courtesy of Francine Seders Gallery, Seattle.

Untitled, 1970s. Oil on canvas. 24 × 20 inches. Collection of the artist; courtesy of Francine Seders Gallery, Seattle.

Flutist No. 1, 1980. Ink on paper. 24 × 18 inches. Collection of Maggie and William Dorsey, Mercer Island, Washington.

Augusta Savage, 1984. Oil on canvas. 36 × 24 inches. Collection of Dr. Gabrielle Reem and Dr. Herbert Kayden, New York.

The Yard, 1987. Oil on Masonite. 23 × 24 inches. Museum Acquisition Fund, Hampton University Art Museum, Hampton, Virginia.

Playing with Baby, 1987. Oil on canvas. 48 × 40 inches. Washington Arts Commission Art in Public Places in partnership with Seattle School District.

Robes, 1987. Oil on canvas. 42⅛ × 30 inches. St. Paul Companies, St. Paul, Minnesota.

Mask IV, 1988. Oil on canvas. 18 × 16 inches. Collection of Microsoft Corporation.

The White Dress, 1989. Oil and pastel on canvas. 36 × 24 inches. Collection of Virginia Wolf.

The Garden, 1989. Oil on canvas. 32 × 26 inches. Collection of Stephanie Kowals and Andrew Dyn, Seattle.

Portrait of the Artist, 1991. Oil on canvas. 20 × 16 inches. Marshall and Helen Hatch Collection.

Pleas and Thank Yous, 1991. Oil on aluminum. 11 × 8½ inches. Lent by The Minneapolis Institute of Arts; The Anne and Hadlai Hull Fund.

Lullaby, 1992. Lithograph. 22 × 30 inches. Collection of the artist; courtesy of Francine Seders Gallery, Seattle.

Pot of Flowers, 1994. Mixed media on paper. 25 × 19 inches. Collection of Ms. Tilman Smith.

Meditation, 1994. Monoprint. 20 × 26 inches. Collection of Eric Mansfield, Seattle.

Moon Walk II, 1994. Monoprint. 26 × 20 inches. Collection of the artist; courtesy of Francine Seders Gallery, Seattle.

Afternoon of a Faun, 1994. Altered monoprint. 26 × 20 inches. Lent by The Minneapolis Institute of Arts; The Ethel Morrison Van Derlip Fund.

African Woman I, 1994. Monoprint. 26 × 20 inches. Collection of Carol Meshbesher and Archie Givens.

Diva, 1994. Serigraph. 28 × 23 inches. Collection of Michèle and Mike Bucy, Seattle.

Horse IV, 1997. Monoprint. 19¾ × 26 inches. Collection of Susan, Annemon and Arluciu Q. Stephens, Seattle.

Horse VI, 1997. Monoprint. 19¾ × 26 inches. Tacoma Art Museum, Gift of Carol Bennett.

Standing, 1999. Etching. 18¼ × 18 inches. Collection of Safeco.

Running, 1999. Etching. 18¼ × 18 inches. Collection of Safeco.

The Stories, 1999. Gouache on paper. 17 × 13 inches. Collection of Yvonne and Alvin McLean.

The White Dress, 1999. Serigraph. 28 × 23 inches. Collection of Microsoft Corporation.

New Orleans, 2001. Serigraph. 22 × 20 inches. Collection of Microsoft Corporation.